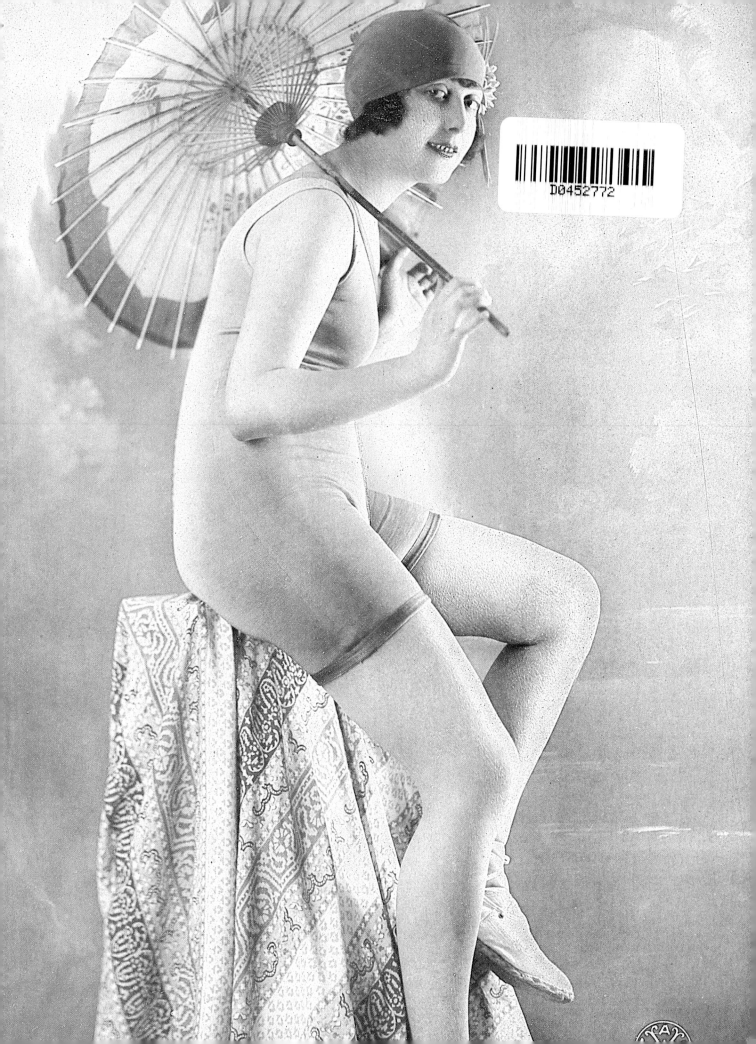

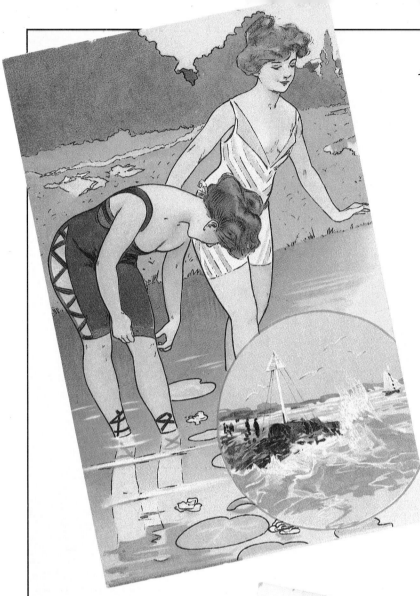

# ACKNOWLEDGMENT

Once again I must acknowledge
my deep debt of gratitude to all
those superb artists, many long
forgotten, whose work shines out
from these pages.
A word, too, for that
wonderful breed, the second-hand
booksellers, without whose
diligence all these pictures might
never see the light of day again.

*Ronnie Barker*

Just found a pebble on the beach at
SOUTHEND-ON-SEA

## PUBLISHER'S NOTE

Great difficulty has been experienced in
tracing copyright of some of the pictures
in this book. We regret if we have
unwittingly failed to give credit to any
individual, and undertake to do so in
future editions of the work upon
notification by the owners of the said
copyright.
British Library Cataloguing
in Publication Data
Barker, Ronnie
    Pebbles on the beach
    i Women in art – Pictorial works
    I Title

ISBN 0 340 35765 7

BOOK DESIGN BY BOB HOOK AND IVOR CLAYDON

# PEBBLES
### ON THE BEACH

by

## RONNIE BARKER

A PICTORIAL TRIBUTE
TO
THE SEASIDE GIRL

HODDER AND STOUGHTON
London  Sydney  Auckland  Toronto

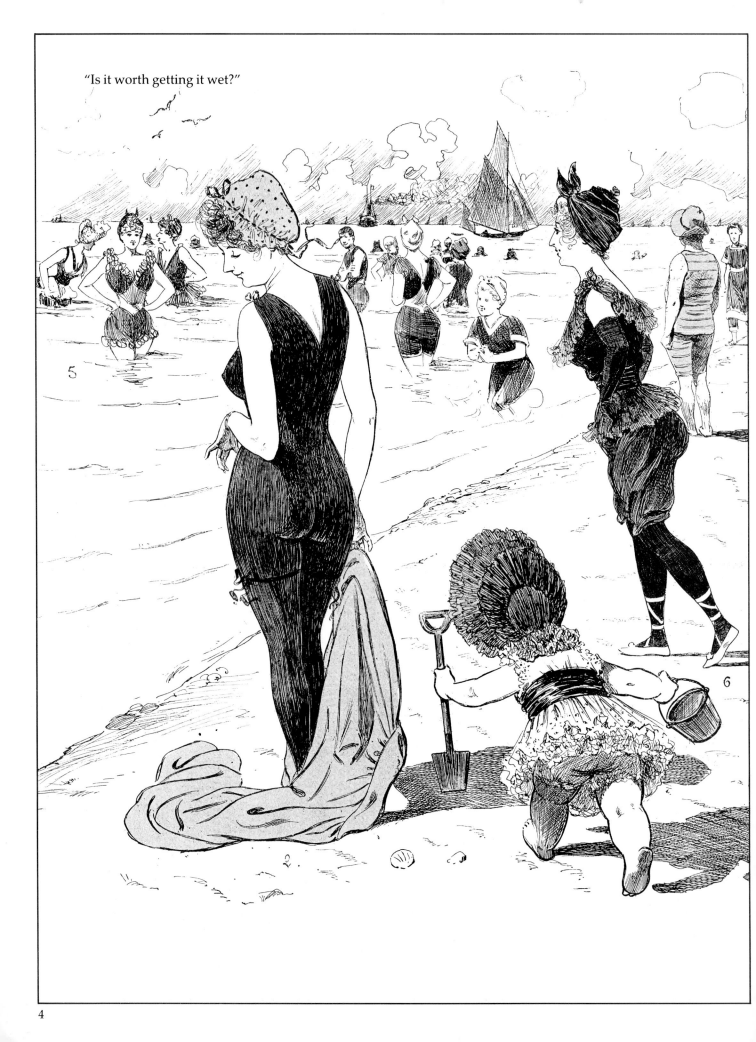

"Is it worth getting it wet?"

# CONTENTS

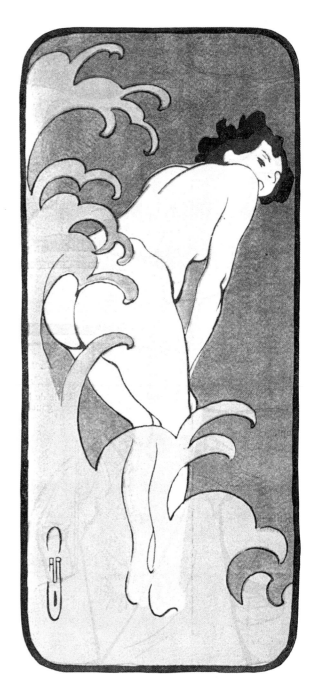

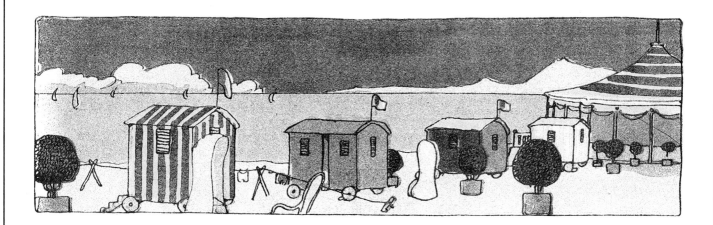

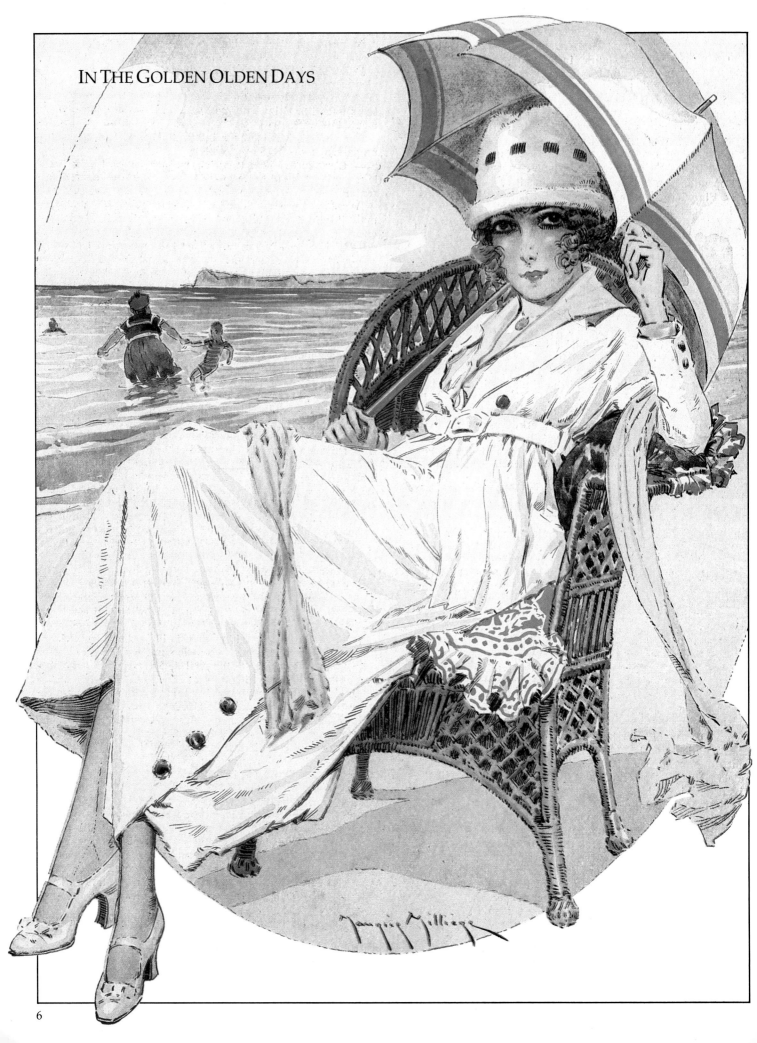

B.WENNERBERG.

# FOREWORD

"Here we are again!" The annual visit to the seaside, in the golden olden days when these delicious drawings and saucy snapshots first appeared, was one of the best-loved of traditions. Fourteen days of sheer escapism, when Mother showed her knees, Father was allowed an extra tipple, little brother Johnnie fashioned bigger and better sand castles, and Sister Susie wowed the boys in her latest and most daring swimwear, as she stooped to gather seashells on the seashore.
I venture to present another feast to the eye for your delight; a picture book of sun, sand and sea, in the days that used to be . . .

In the Golden Olden Days,
In the Golden Olden Days,
Sweet familiar music
The hurdy-gurdy plays.
We used to pass the hours
In a hundred different ways
In those fun-filled, sun-filled, lazy,
    hazy,
Golden Olden days.

By the shining, silver sea,
By the shining, silver sea.
Those afternoons among the
    dunes,
When you gave your heart to me.
'Neath sparkling sun we were as
    one
And swore we'd always be,
By the tireless tinkling,
Tossing, twinkling,
Shining, silver sea.

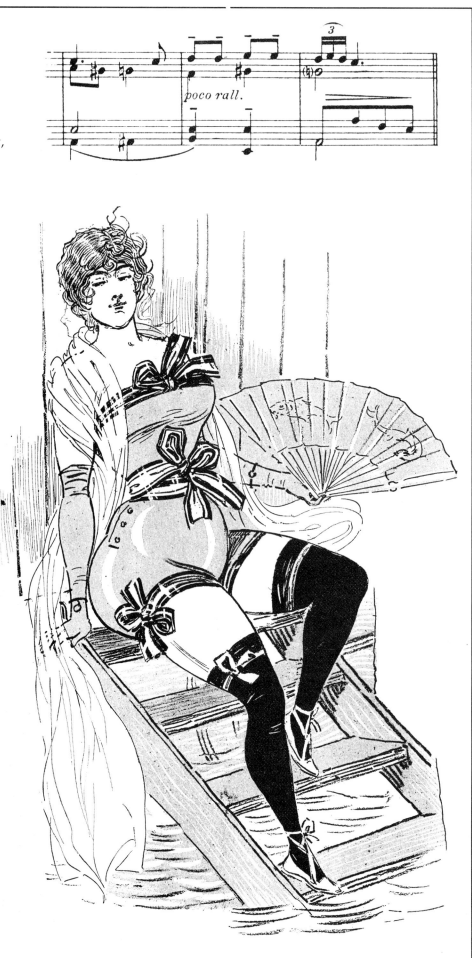

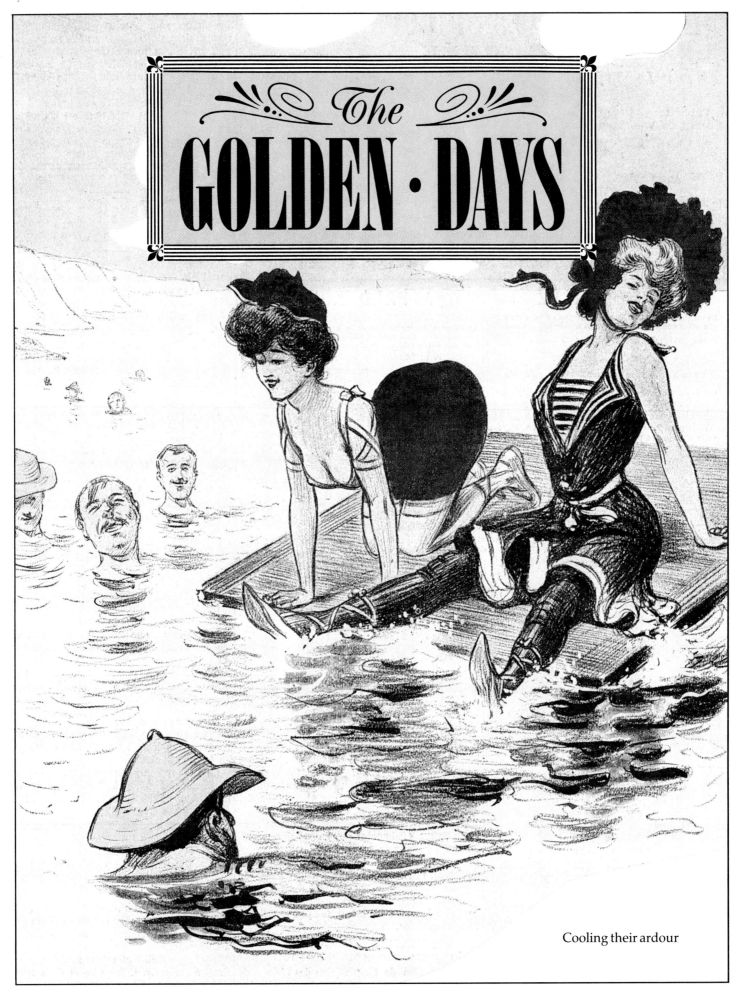

# The GOLDEN · DAYS

Cooling their ardour

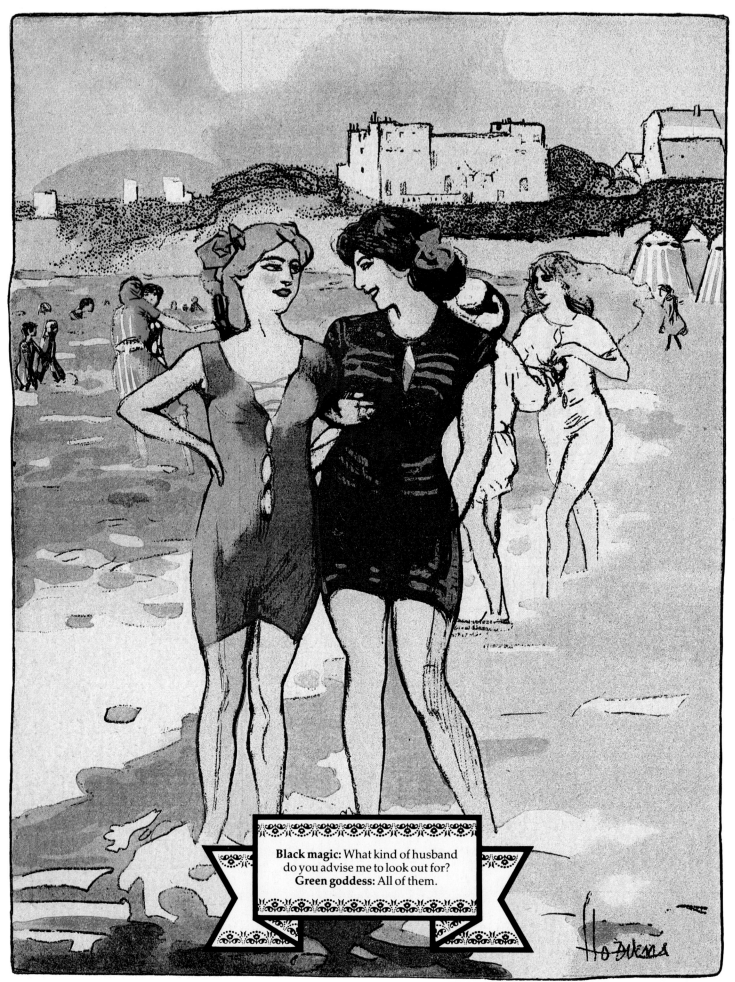

**Black magic:** What kind of husband do you advise me to look out for?
**Green goddess:** All of them.

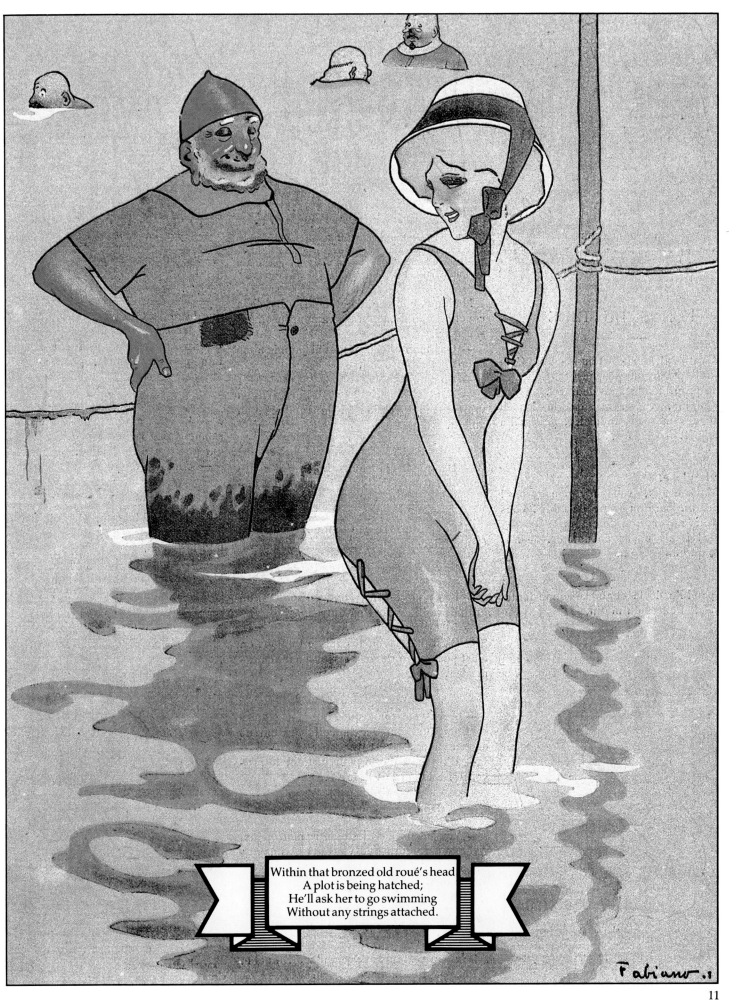

Within that bronzed old roué's head
A plot is being hatched;
He'll ask her to go swimming
Without any strings attached.

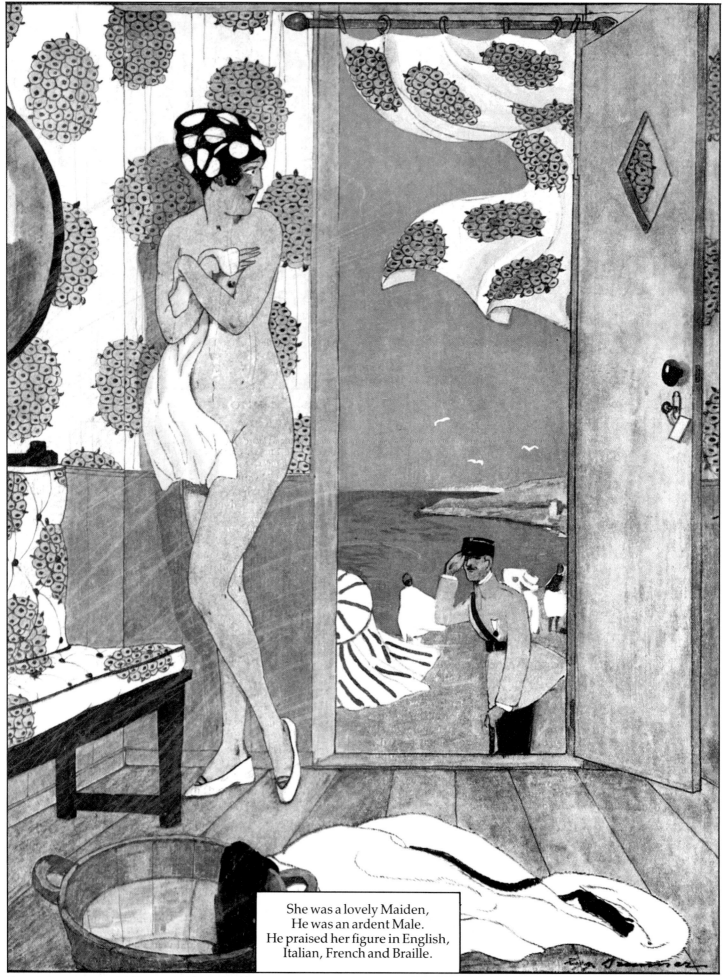

She was a lovely Maiden,
He was an ardent Male.
He praised her figure in English,
Italian, French and Braille.

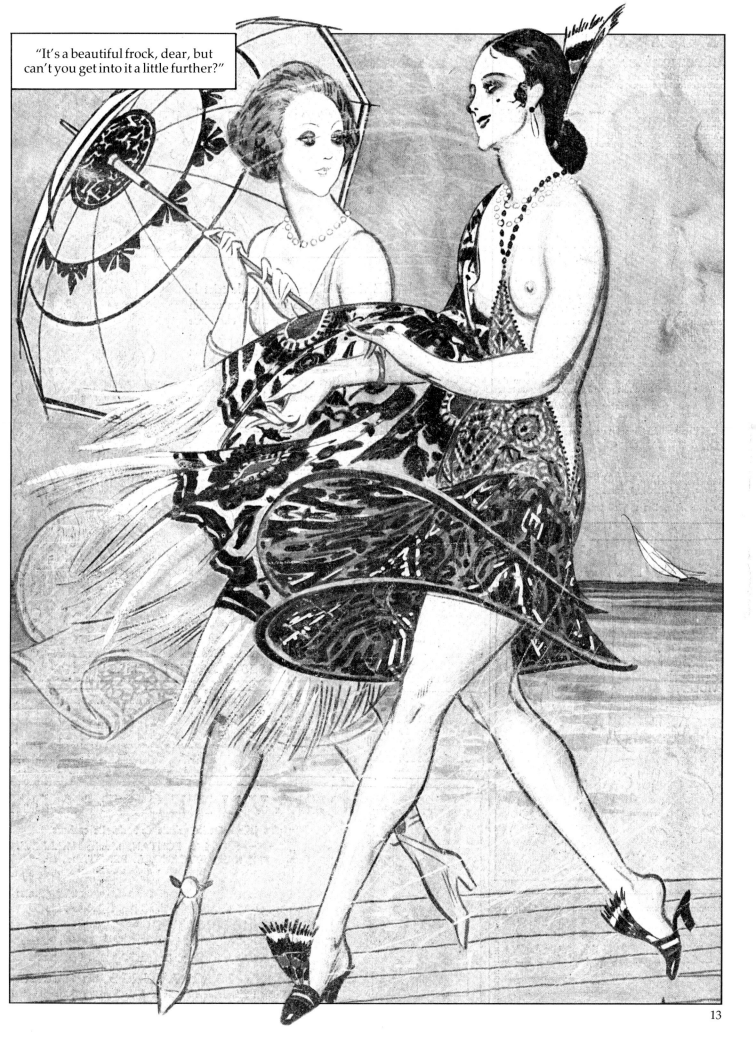

"It's a beautiful frock, dear, but can't you get into it a little further?"

**Old hopeful:** You called me, Madam?
**Young tease:** I'm frightfully sorry, I was mistaken.
Your head looks terribly like my husband's, behind.

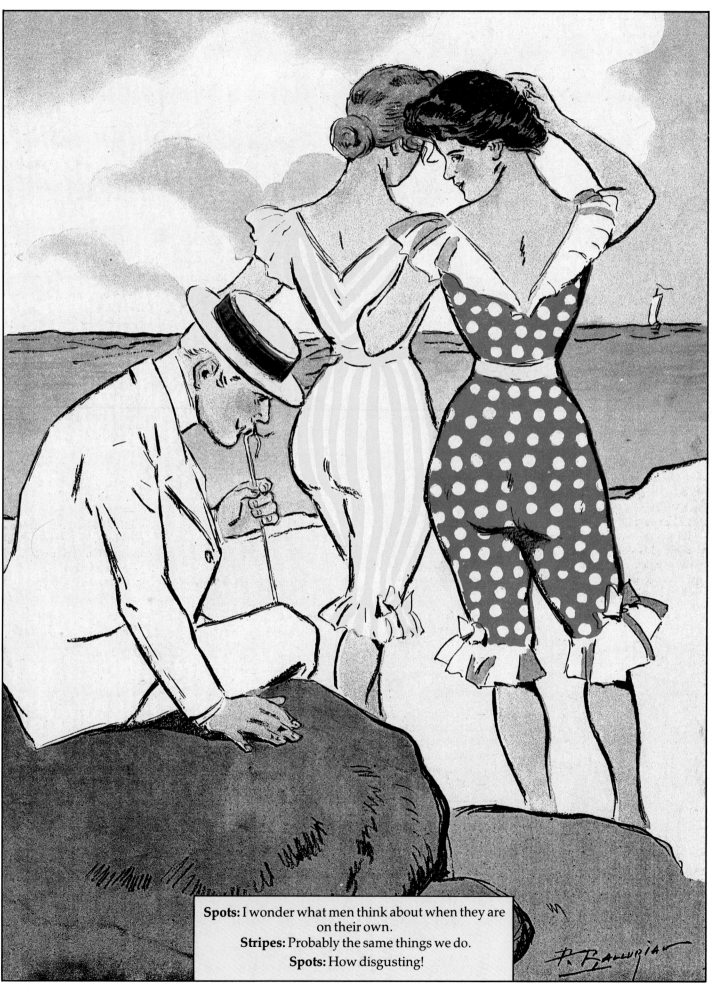

**Spots:** I wonder what men think about when they are on their own.
**Stripes:** Probably the same things we do.
**Spots:** How disgusting!

# GOODNESS

Good place,
good weather,
good views,
good sand,
good digs,
good table,
good waiter,
good band;
good wine,
good soup,
good fish,
good duck,
good brandy,
good night –
good girl.
Bad luck.

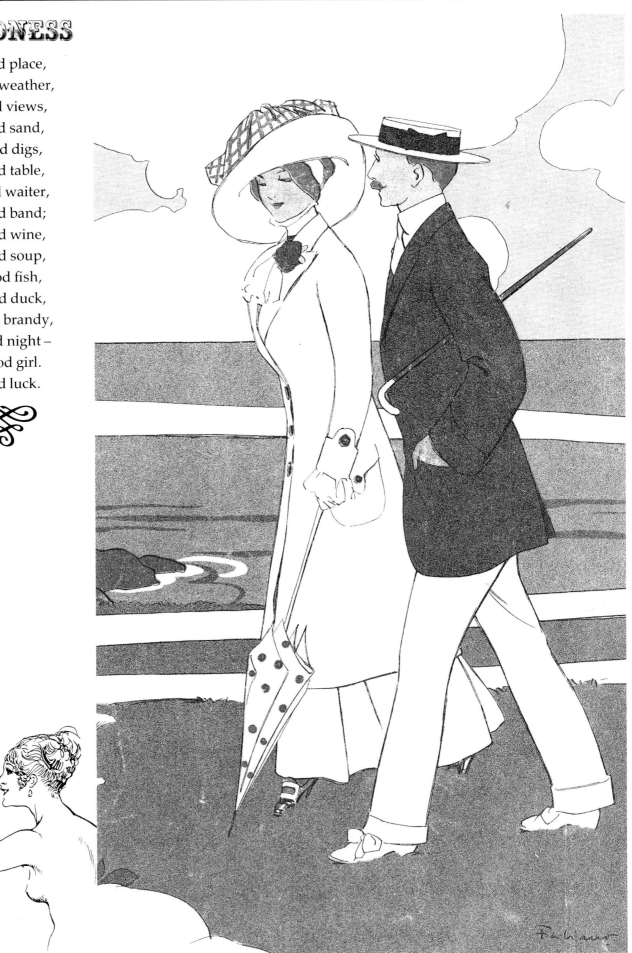

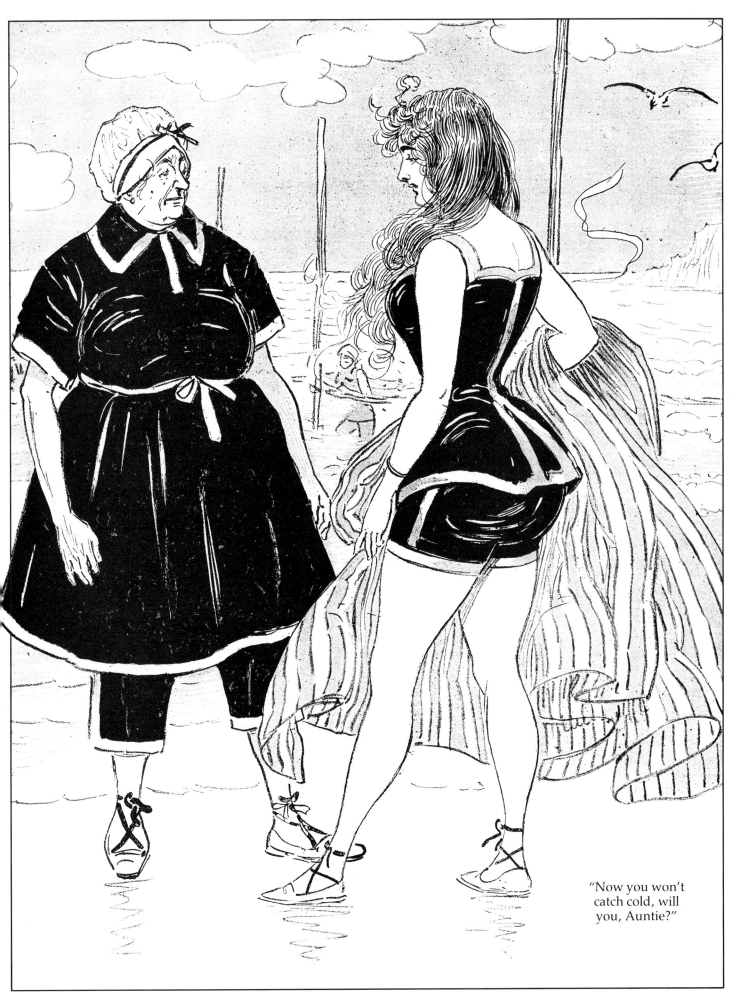

"Now you won't catch cold, will you, Auntie?"

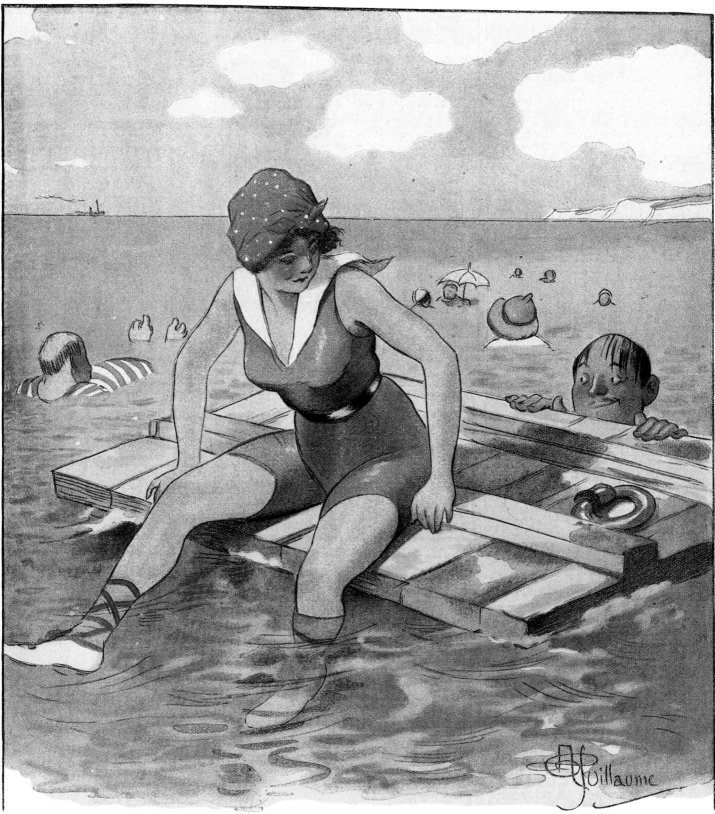

**He:** Do you know what it's like to
feel your innermost soul vibrate?
**She:** Yes, my boy-friend has a motorbike.

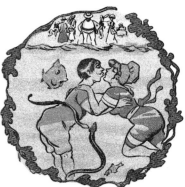

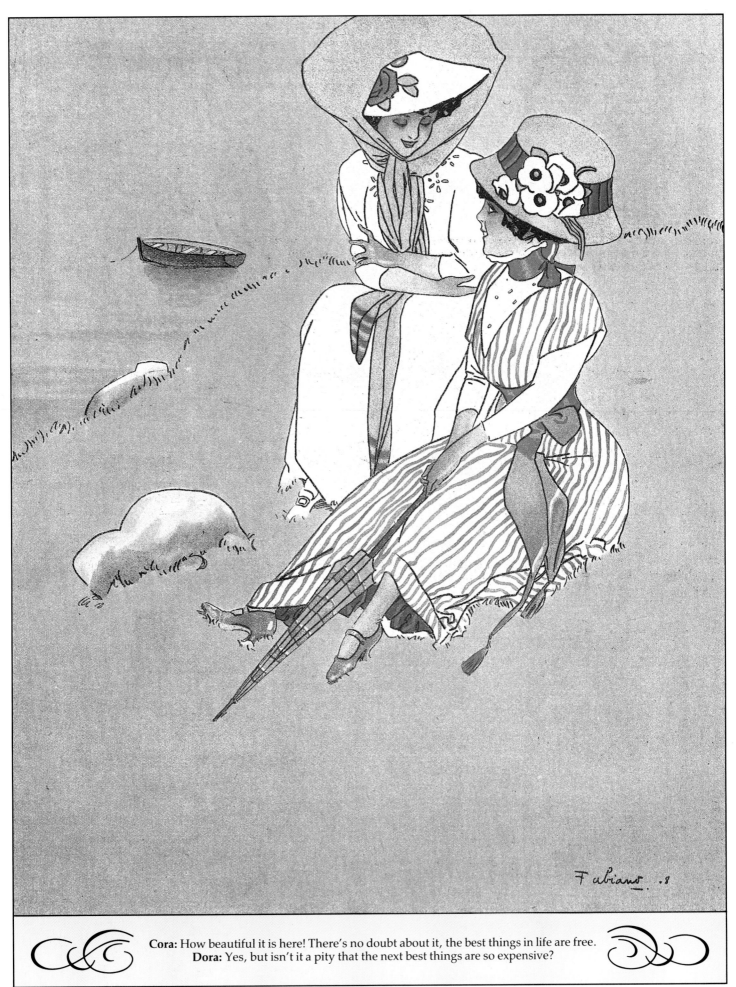

**Cora:** How beautiful it is here! There's no doubt about it, the best things in life are free.
**Dora:** Yes, but isn't it a pity that the next best things are so expensive?

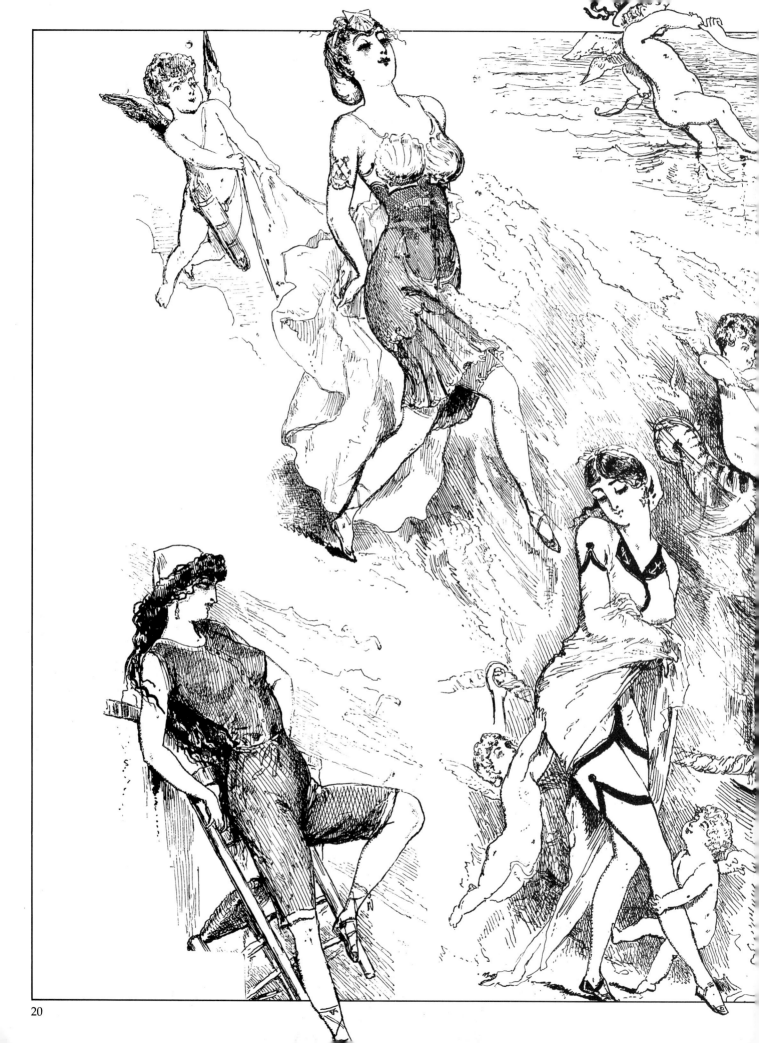

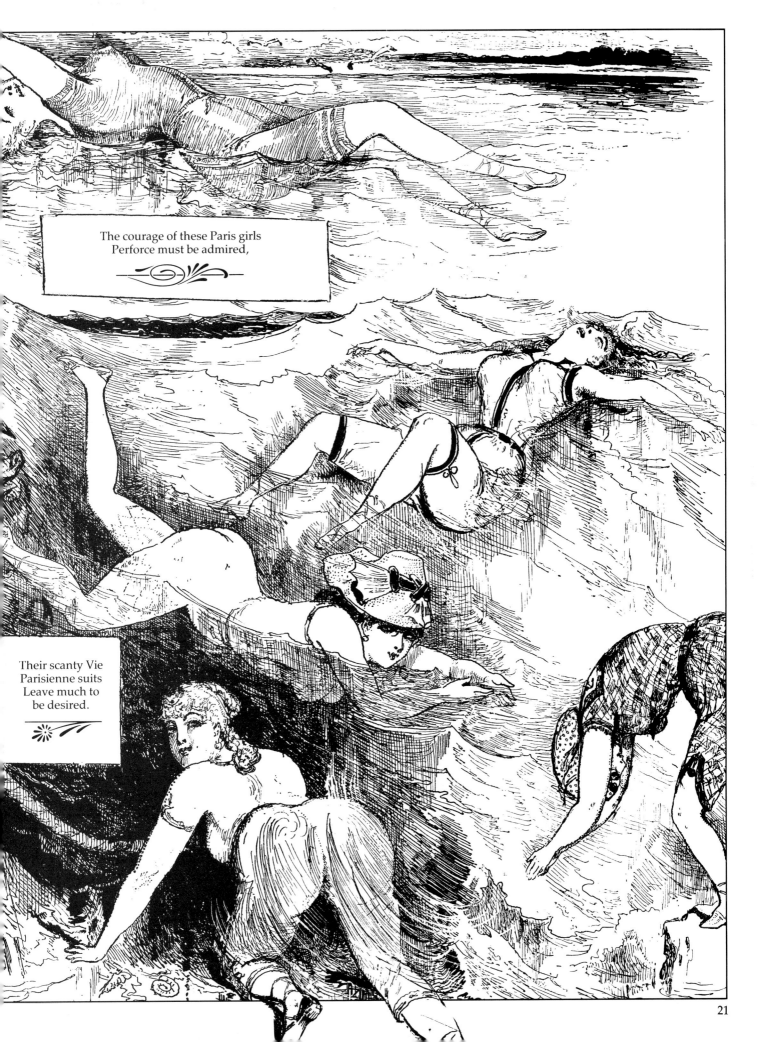

The courage of these Paris girls
Perforce must be admired,

Their scanty Vie
Parisienne suits
Leave much to
be desired.

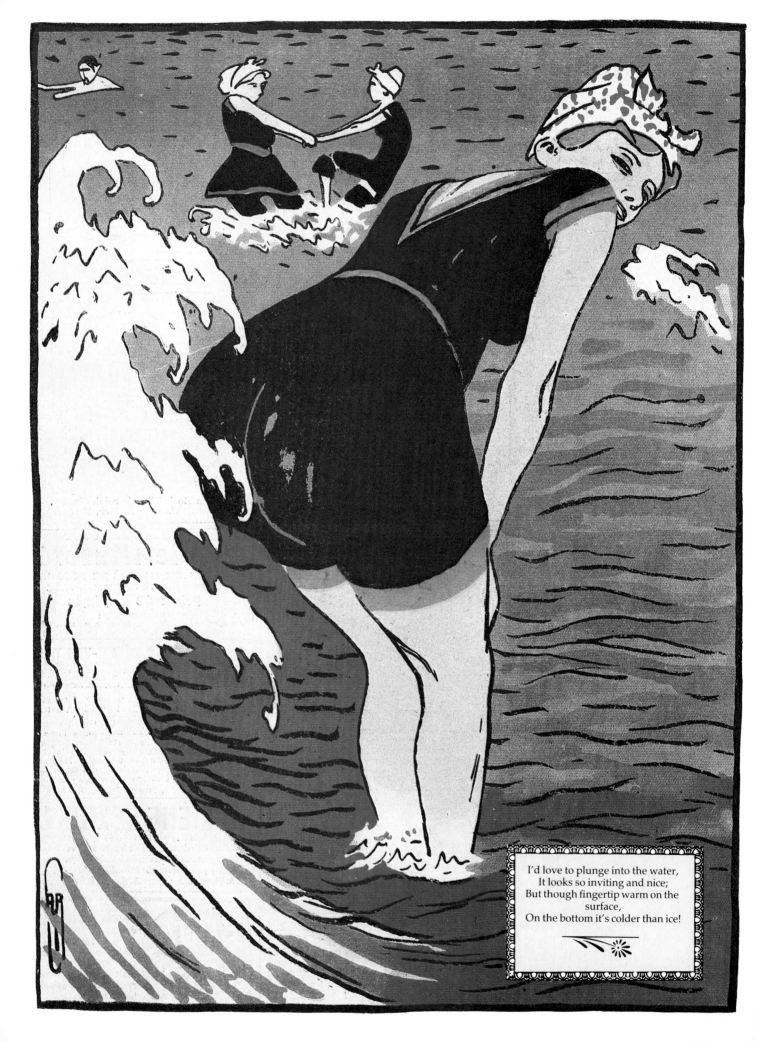

I'd love to plunge into the water,
It looks so inviting and nice;
But though fingertip warm on the surface,
On the bottom it's colder than ice!

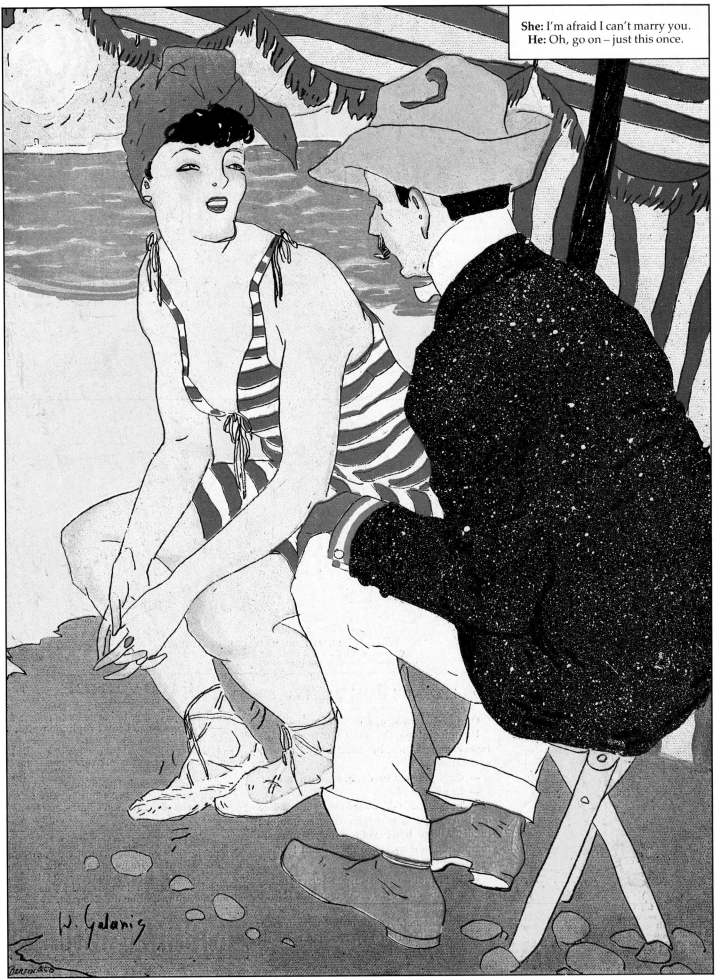

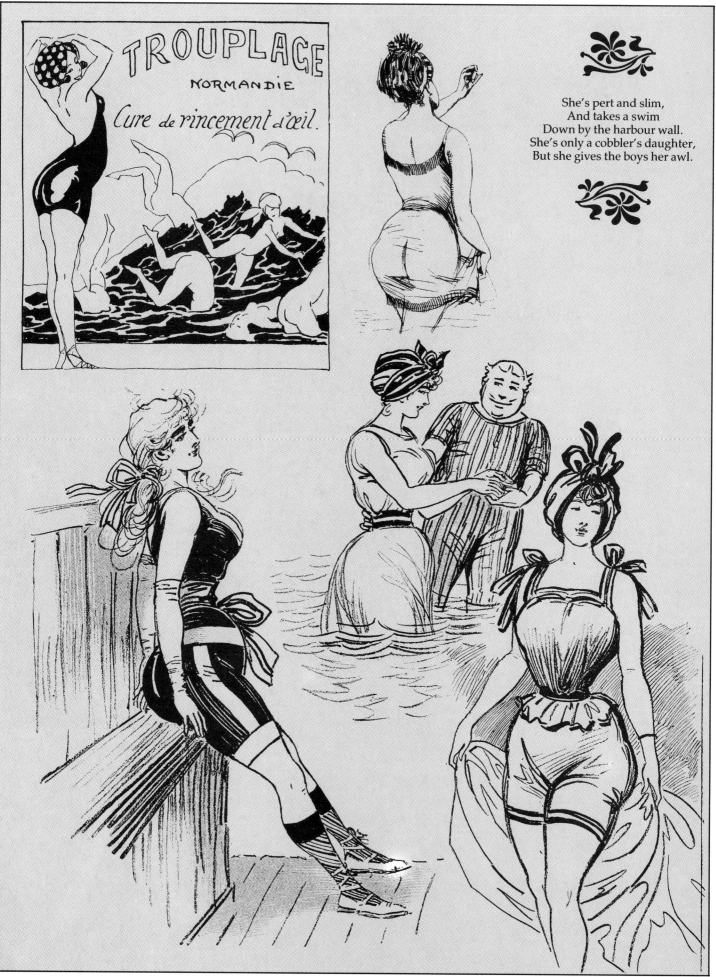

She's pert and slim,
And takes a swim
Down by the harbour wall.
She's only a cobbler's daughter,
But she gives the boys her awl.

24

# GENEROSITY

He gave her this, he gave her that,
A brand new car, a Paris hat.
He gave her dollars, gave her pounds.
His generosity knew no bounds.
He spent it all, became flat broke;
She thought it all a great big joke.
To him the joke was not so funny —
He had to marry her for his money.

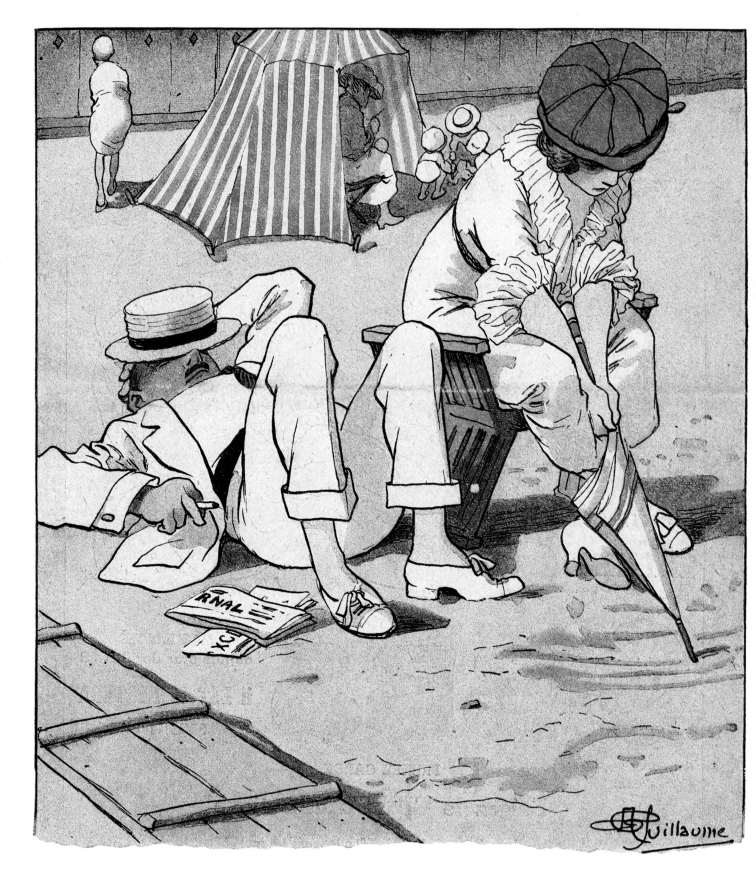

**He:** You think this place is dull? A few miles down the coast
is a place called Walton-on-Sludge.
**She:** Is that worse?
**He:** Worse? Last week the tide went out and never came back.

**Sea-nymph:** Do you like her?
**Bosom friend:** Well, she's got a good heart and means well.
**Sea-nymph:** Neither do I.

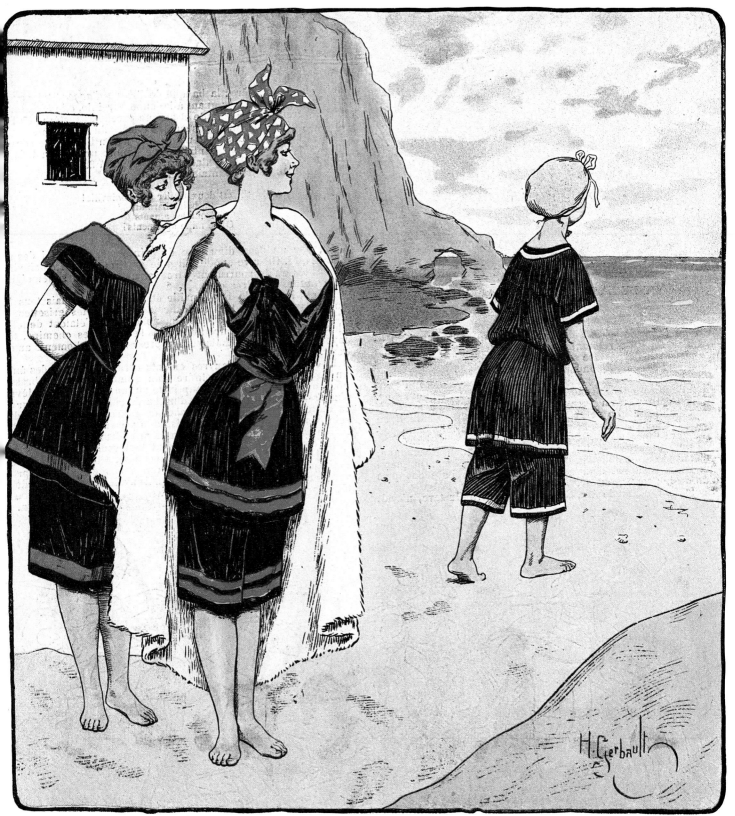

# On · The · Rocks

He used to love me on the sand.
His arms were strong, his cheeks were tanned.
But sand will spoil a girl's best frocks,
So now our love is on the rocks.

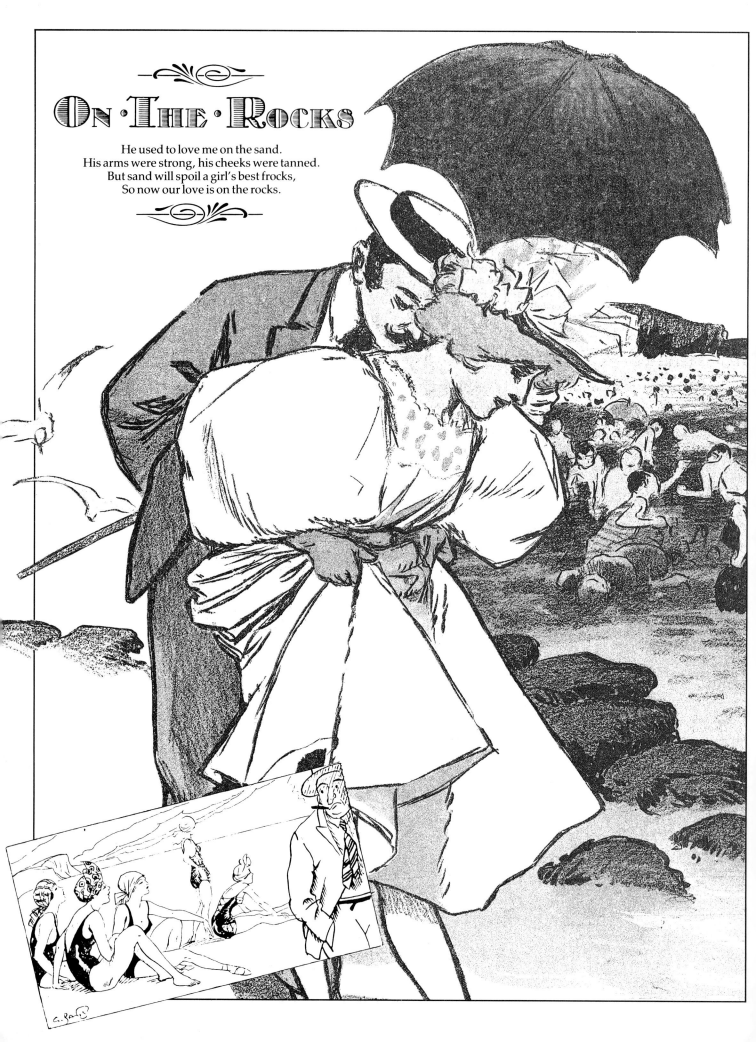

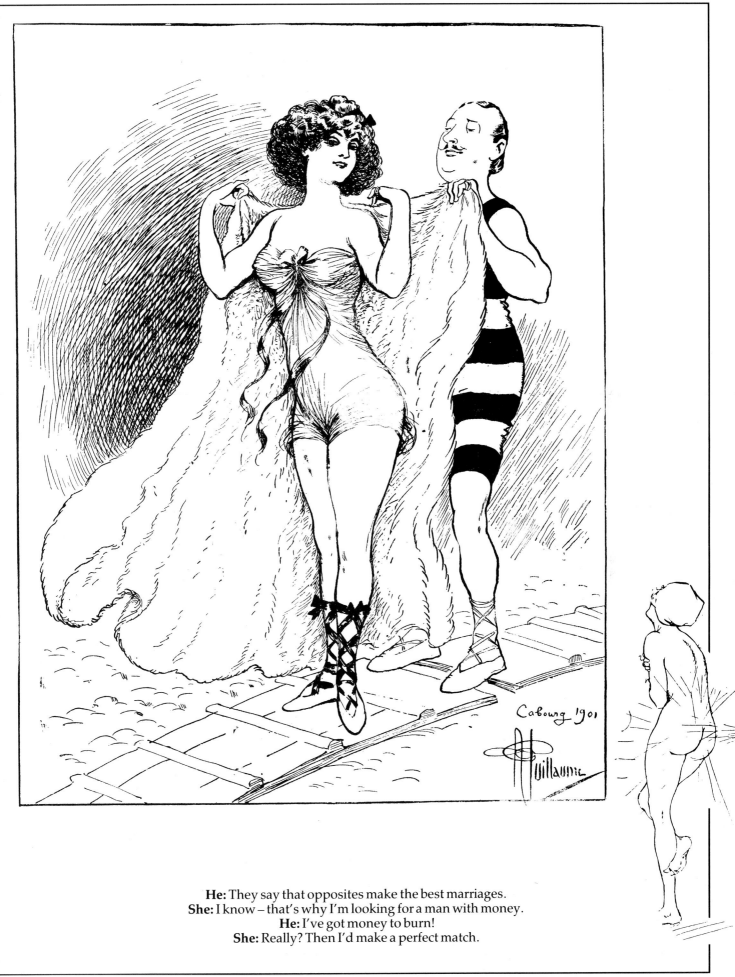

**He:** They say that opposites make the best marriages.
**She:** I know – that's why I'm looking for a man with money.
**He:** I've got money to burn!
**She:** Really? Then I'd make a perfect match.

29

# MERMAIDS

### AND OTHER FANTASIES

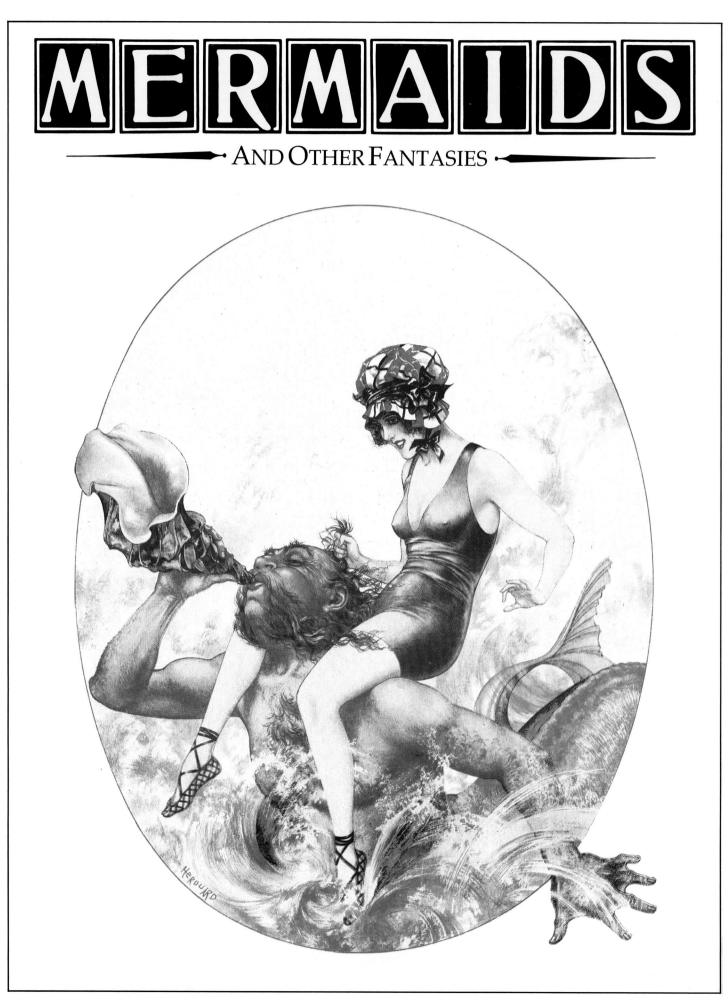

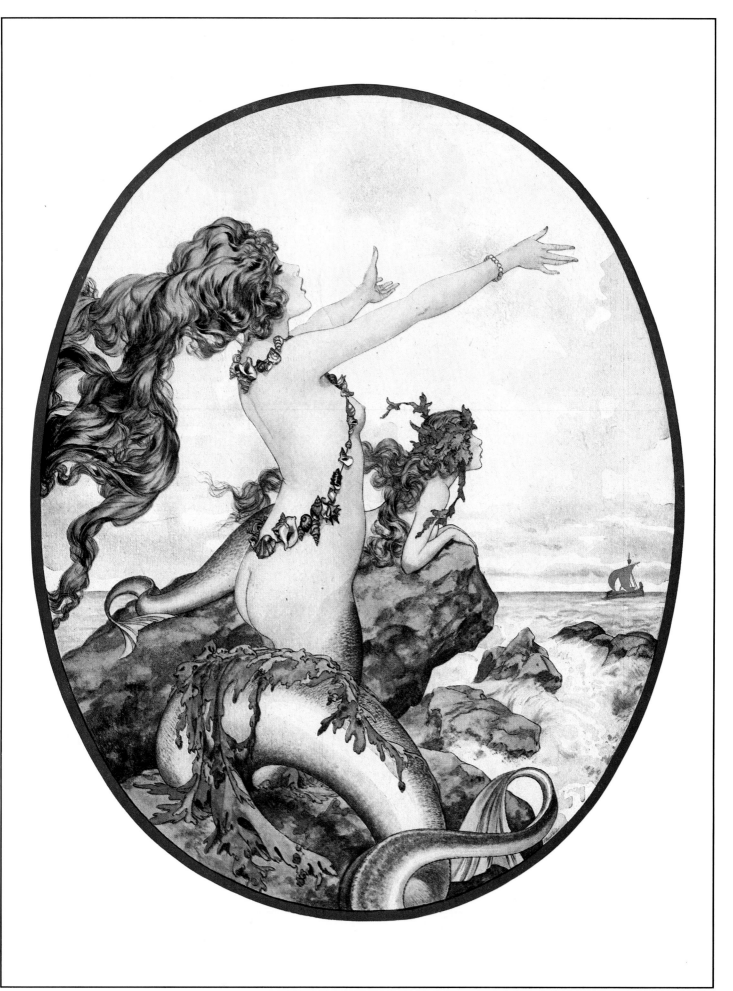

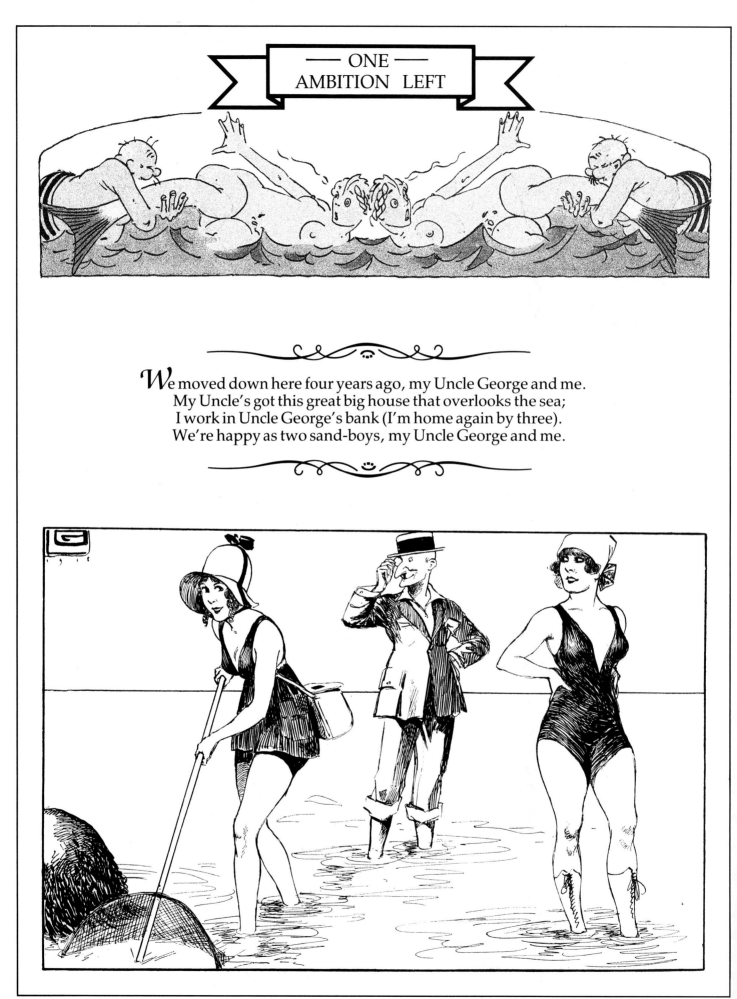

## ONE AMBITION LEFT

*W*e moved down here four years ago, my Uncle George and me.
My Uncle's got this great big house that overlooks the sea;
I work in Uncle George's bank (I'm home again by three).
We're happy as two sand-boys, my Uncle George and me.

We're definitely ladies' men, my Uncle George and me.
Maids of every shape and size are all pursued with glee.
"A milkmaid or a barmaid, Jack, they're all the same to me,"
Says Uncle George. "A maid's a maid, and ever so will be."

———

We've had all sorts of serving maids, my Uncle George and me.
A parlour-maid to tend the fire, and bring us cups of tea;
A kitchen-maid, an upstairs-maid, a house-maid, too, you see –
But we've never had a Mermaid, my Uncle George and me.

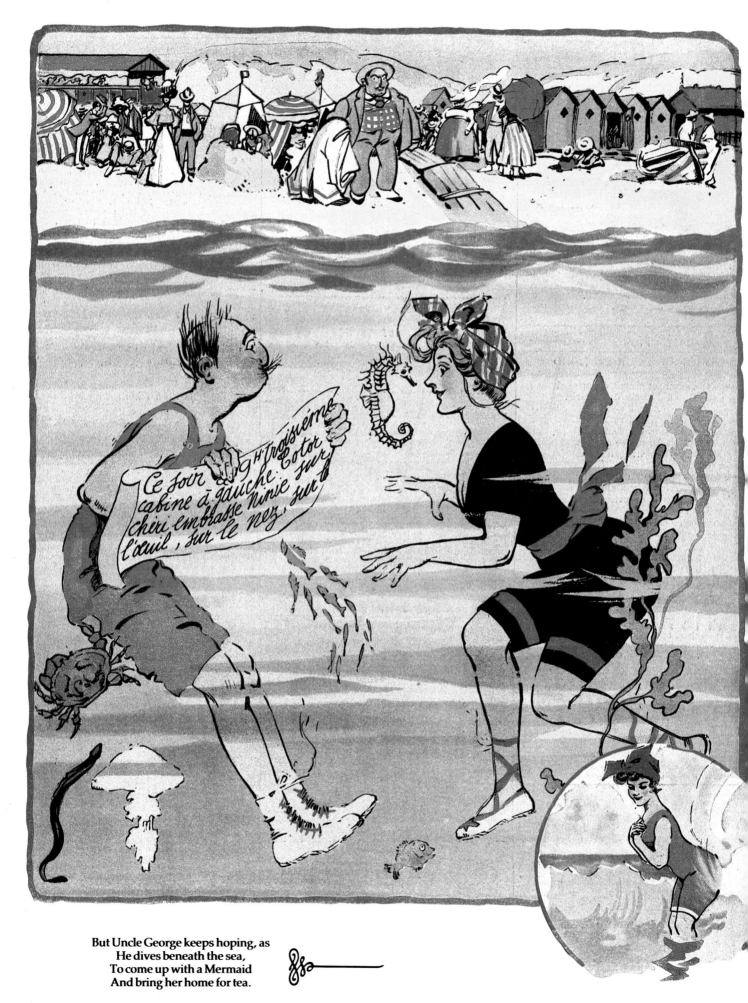

But Uncle George keeps hoping, as
He dives beneath the sea,
To come up with a Mermaid
And bring her home for tea.

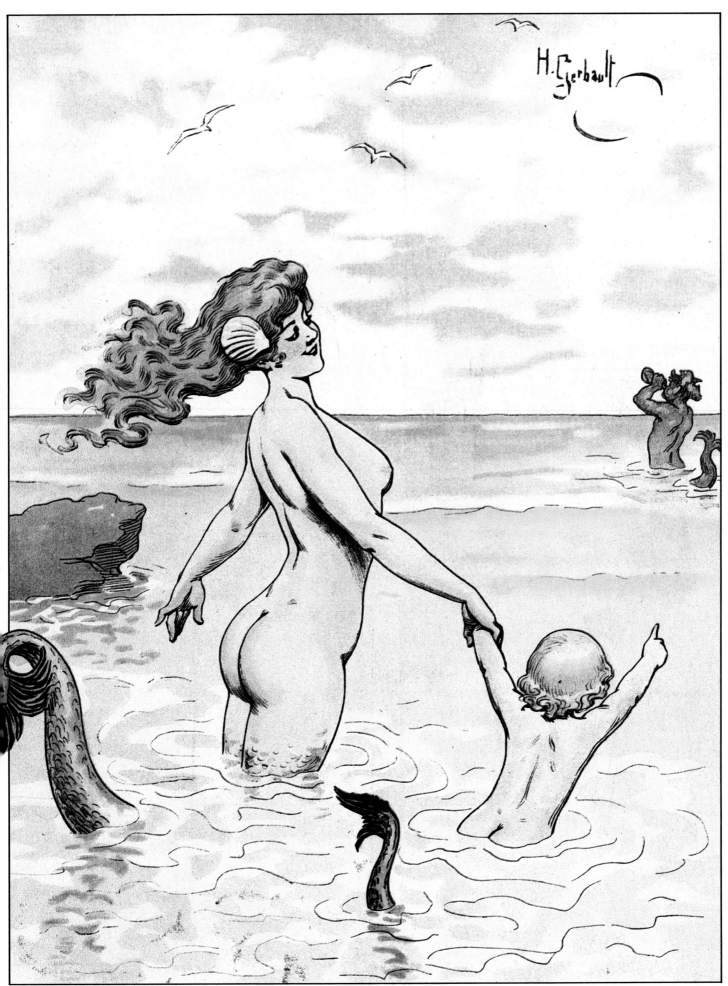

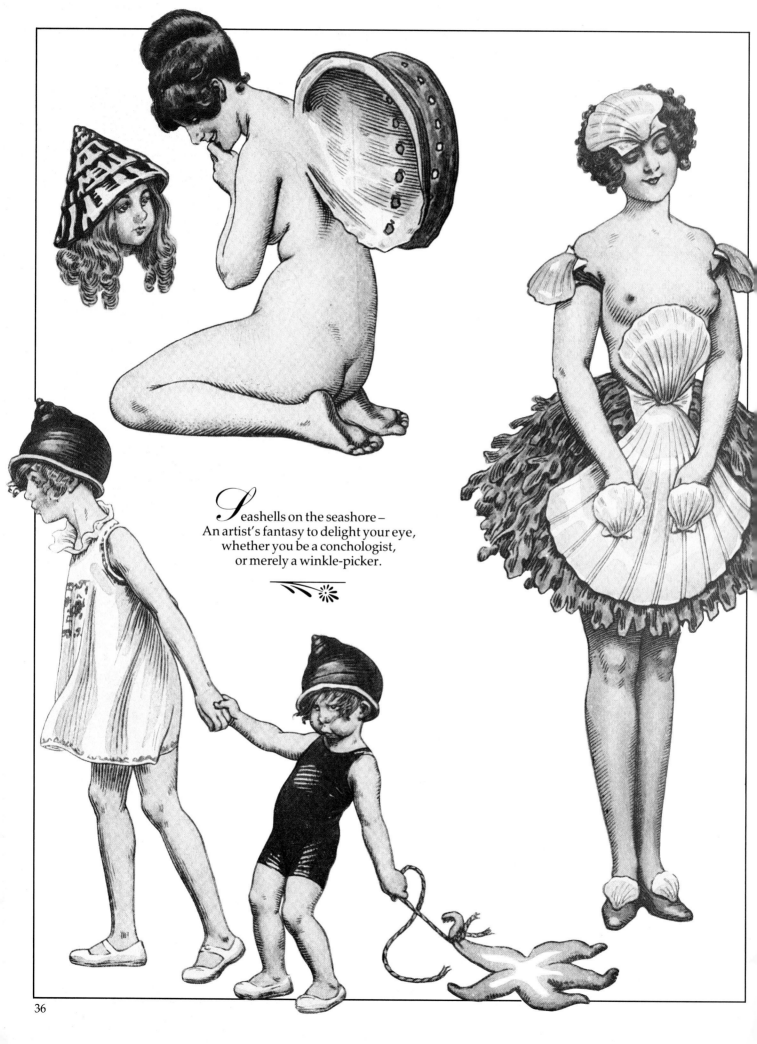

*S*eashells on the seashore –
An artist's fantasy to delight your eye,
whether you be a conchologist,
or merely a winkle-picker.

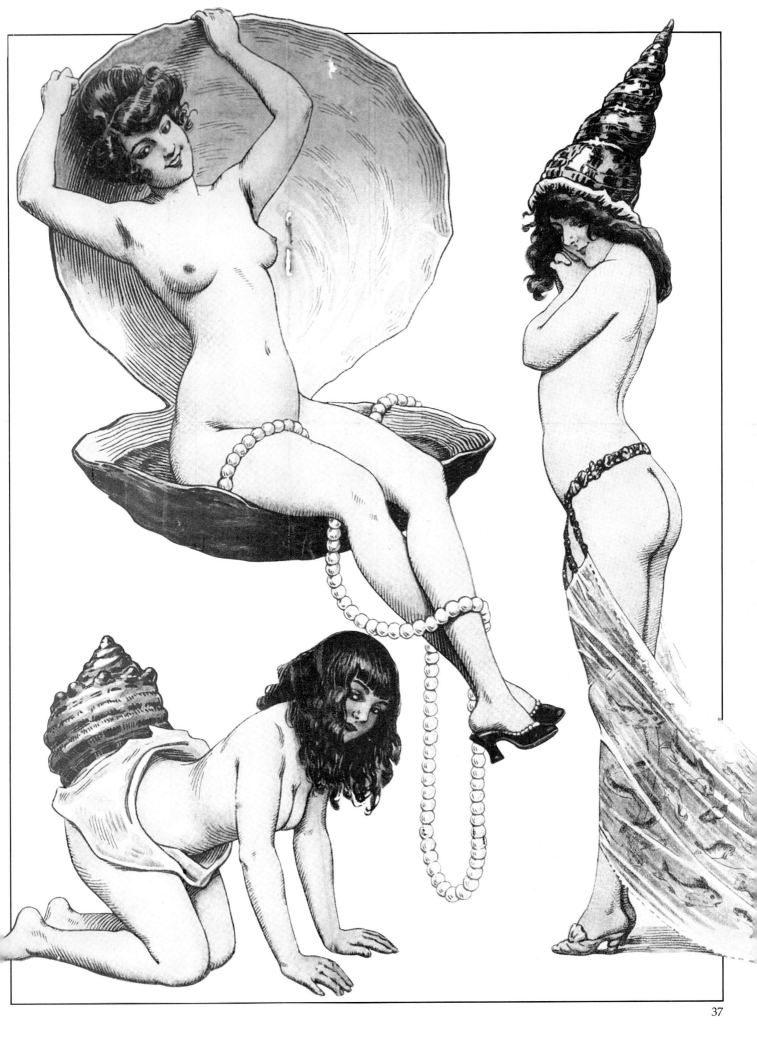

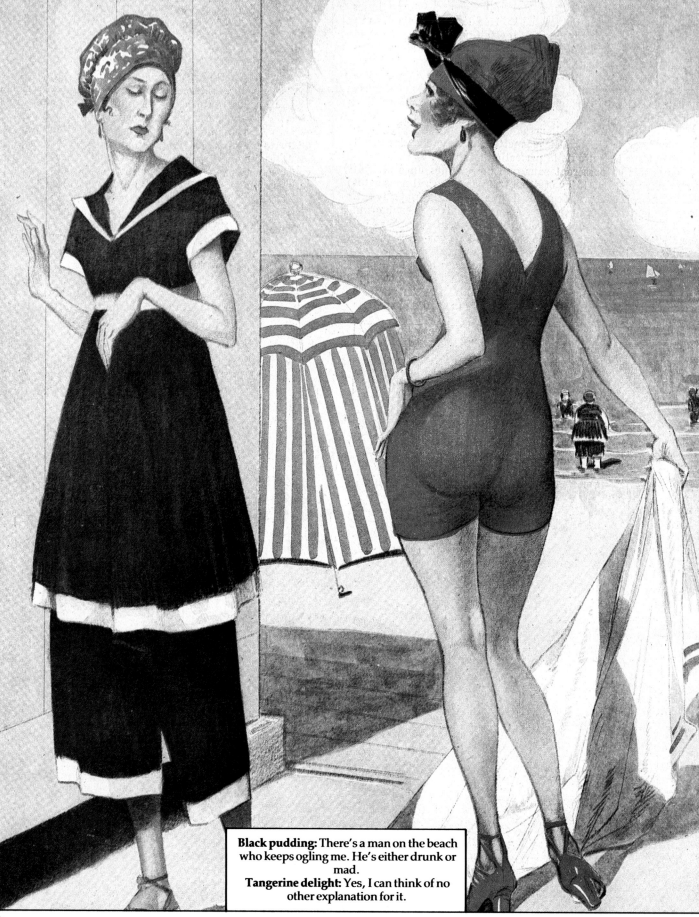

**Black pudding:** There's a man on the beach who keeps ogling me. He's either drunk or mad.
**Tangerine delight:** Yes, I can think of no other explanation for it.

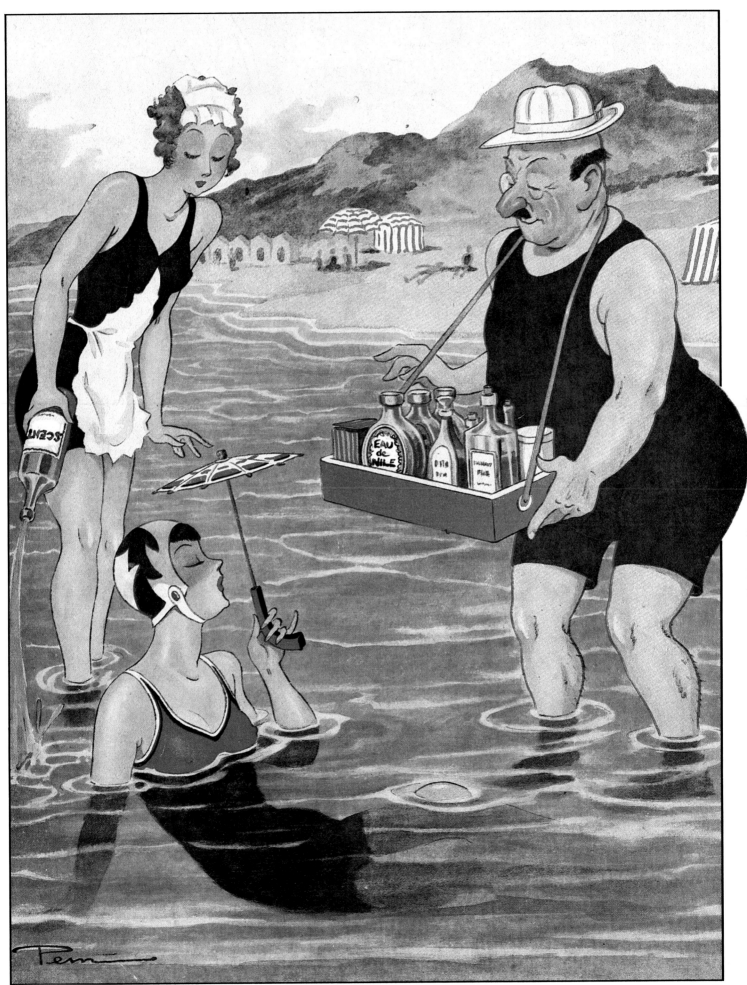

# The
# HUMOUR · OF · THE · BEACH

One cannot think of a seaside holiday, without calling to mind the comic postcard. The double-meaning caption, the sometimes subtle, sometimes explicit drawing to go with it are an essential ingredient of any pier or promenade worthy of the name.

So naturally some are included here; boisterous, bracing, bright and breezy, like the sea itself. People like a laugh at the seaside, and the chance to send a card and brighten up the drab lives back at the factory or the office is too good to miss.

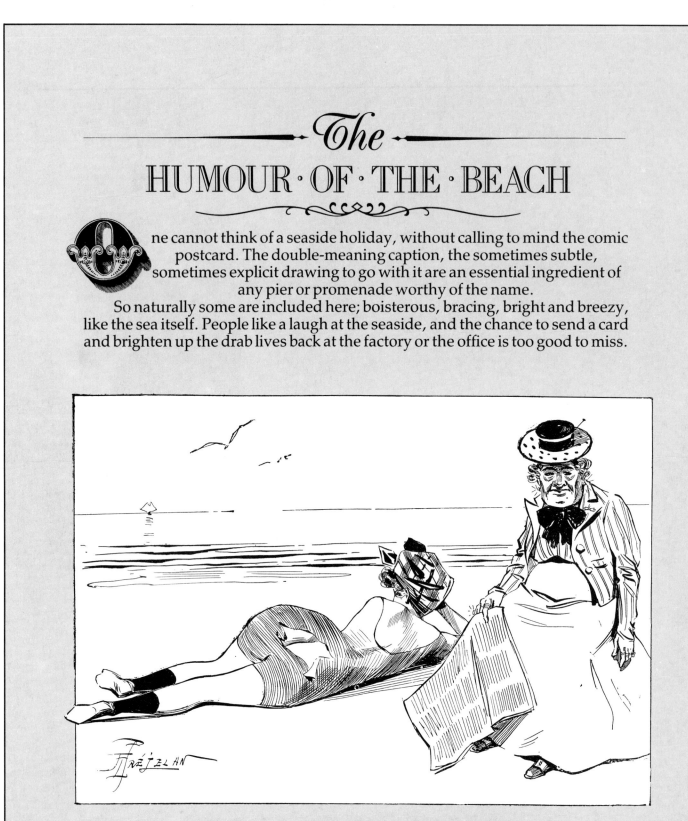

**Beauty's servant:** We're broke again, and there she lies, sunning herself, with never a thought of the out-goings.

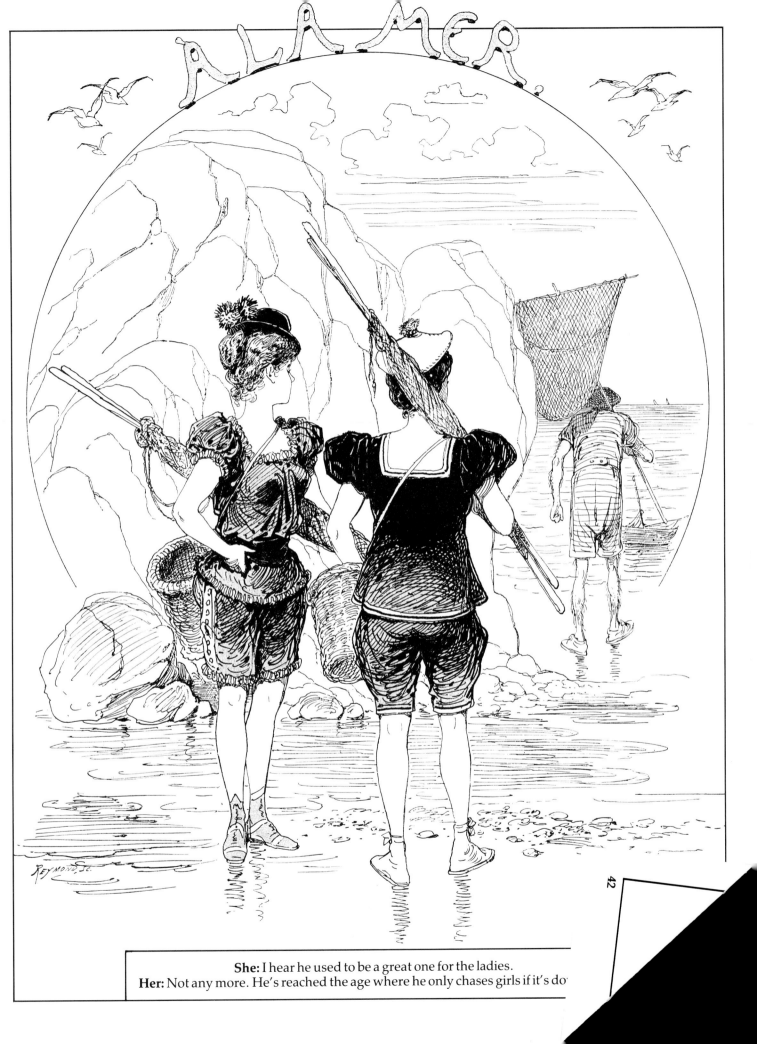

**She:** I hear he used to be a great one for the ladies.
**Her:** Not any more. He's reached the age where he only chases girls if it's do[

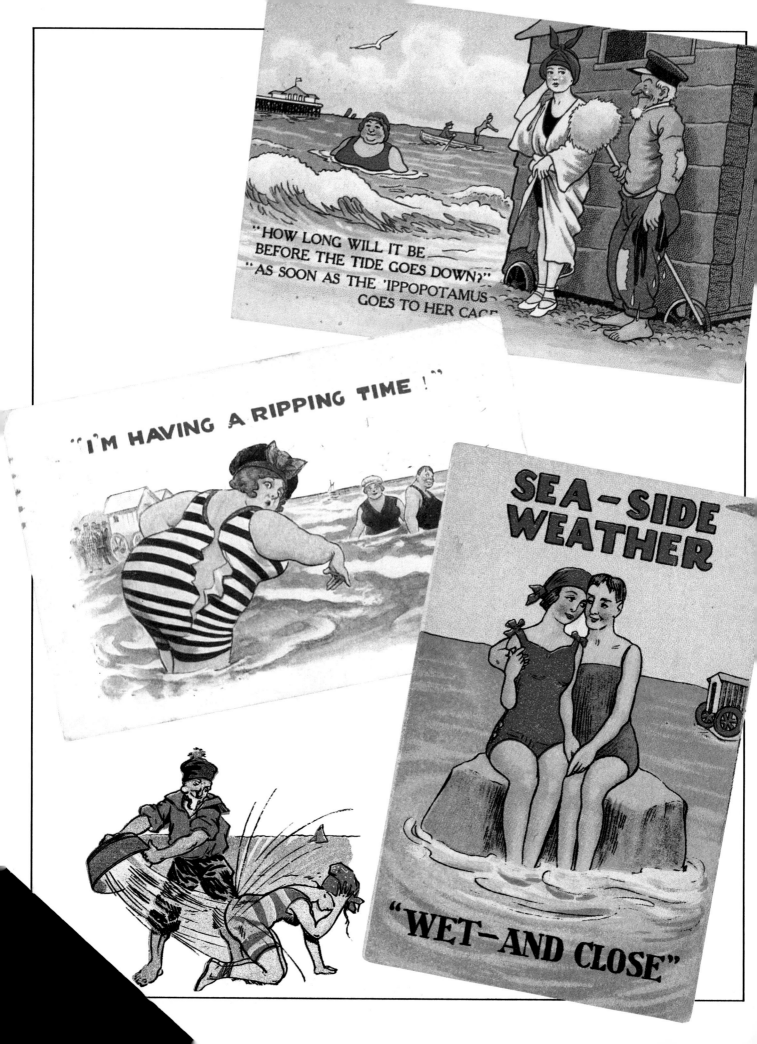

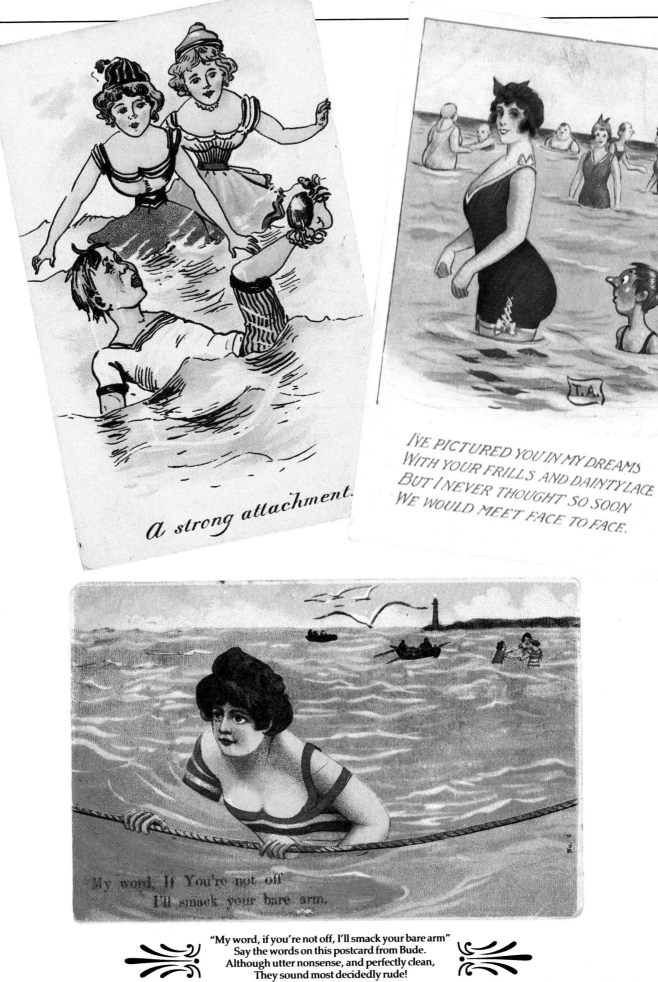

A strong attachment.

I'VE PICTURED YOU IN MY DREAMS
WITH YOUR FRILLS AND DAINTY LACE
BUT I NEVER THOUGHT SO SOON
WE WOULD MEET FACE TO FACE.

My word, If You're not off
I'll smack your bare arm.

"My word, if you're not off, I'll smack your bare arm"
Say the words on this postcard from Bude.
Although utter nonsense, and perfectly clean,
They sound most decidedly rude!

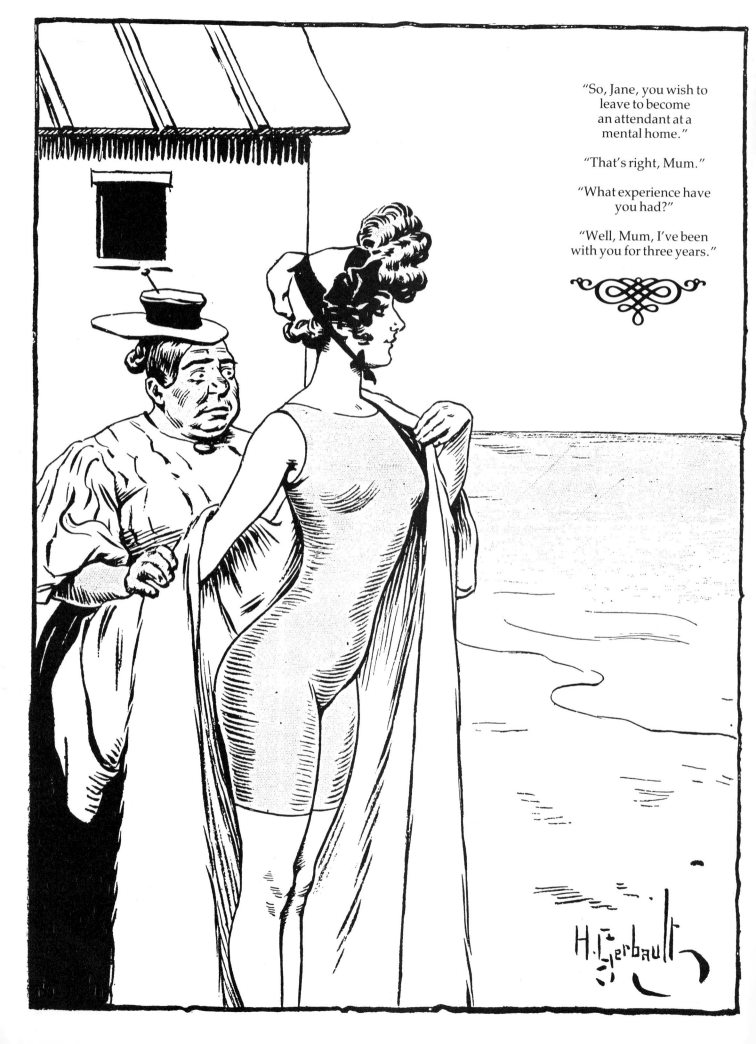

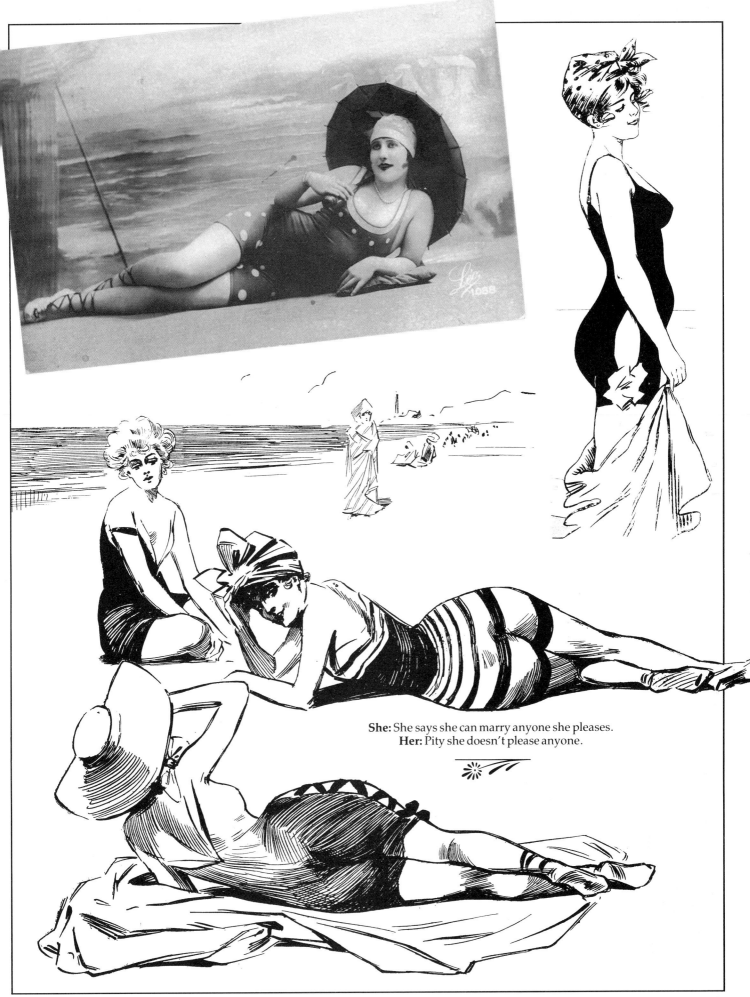

**She:** She says she can marry anyone she pleases.
**Her:** Pity she doesn't please anyone.

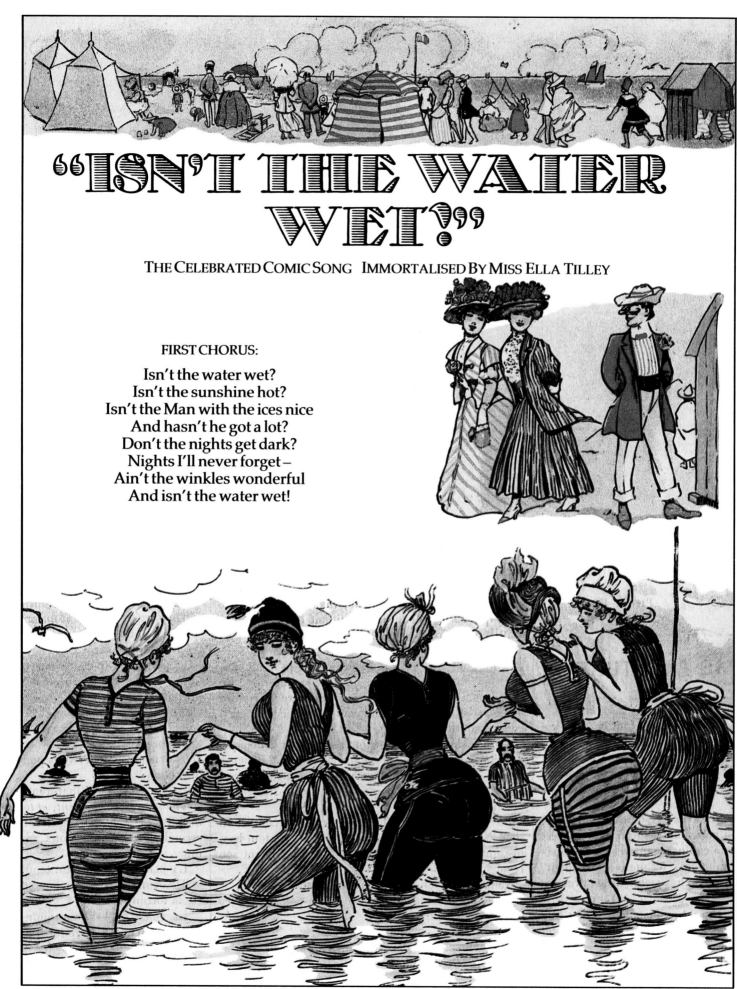

# "ISN'T THE WATER WET?"

### THE CELEBRATED COMIC SONG  IMMORTALISED BY MISS ELLA TILLEY

FIRST CHORUS:

Isn't the water wet?
Isn't the sunshine hot?
Isn't the Man with the ices nice
And hasn't he got a lot?
Don't the nights get dark?
Nights I'll never forget –
Ain't the winkles wonderful
And isn't the water wet!

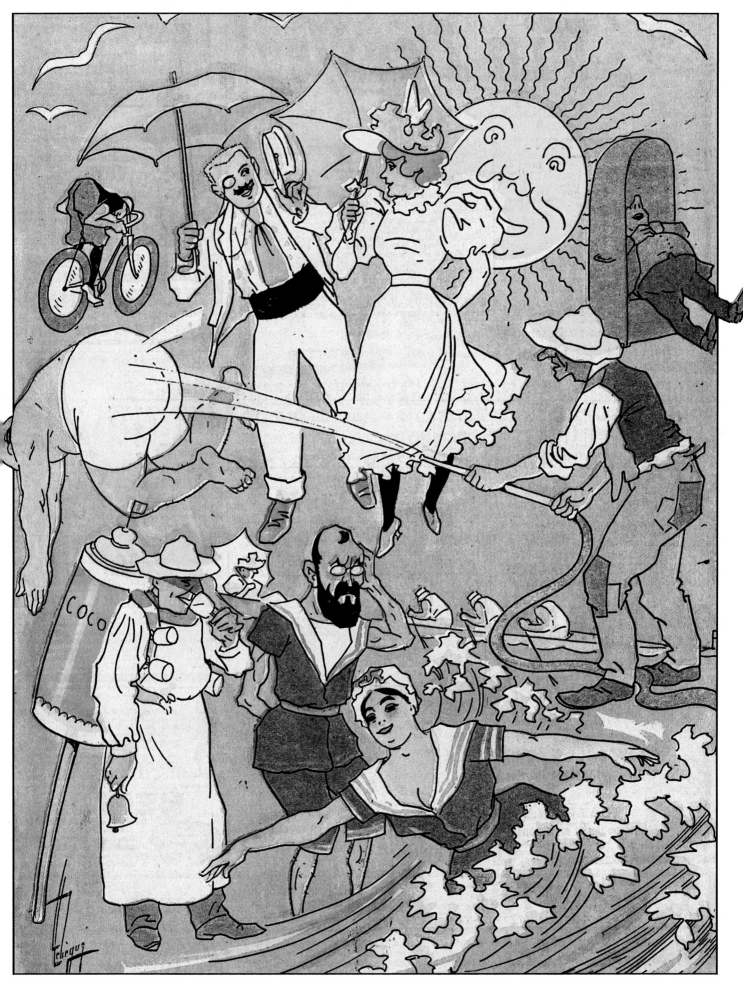

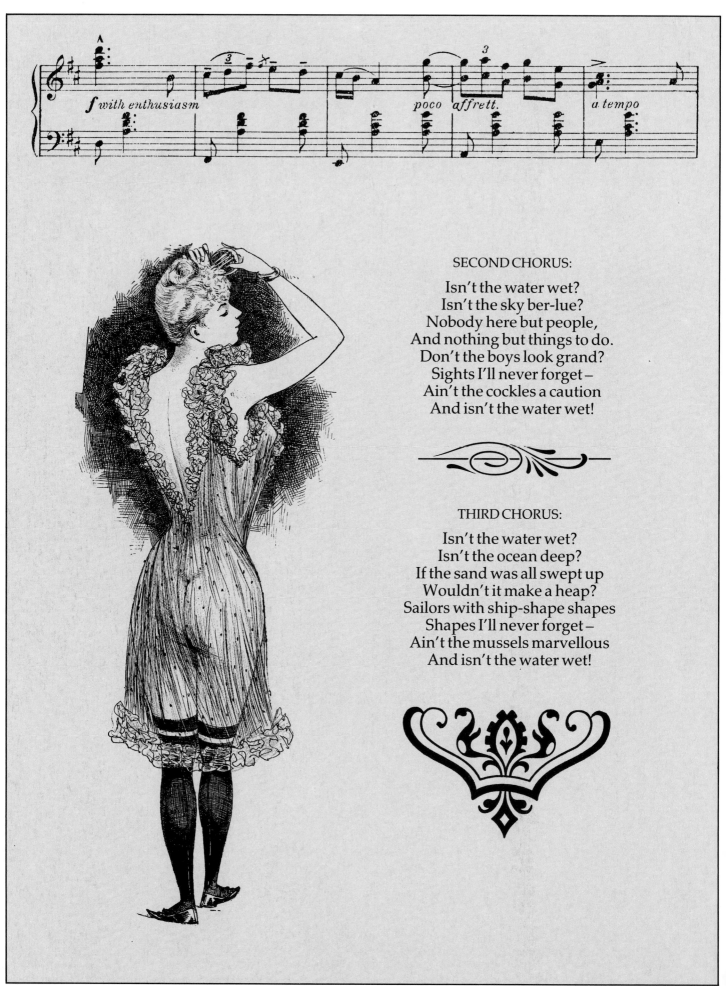

SECOND CHORUS:

Isn't the water wet?
Isn't the sky ber-lue?
Nobody here but people,
And nothing but things to do.
Don't the boys look grand?
Sights I'll never forget –
Ain't the cockles a caution
And isn't the water wet!

THIRD CHORUS:

Isn't the water wet?
Isn't the ocean deep?
If the sand was all swept up
Wouldn't it make a heap?
Sailors with ship-shape shapes
Shapes I'll never forget –
Ain't the mussels marvellous
And isn't the water wet!

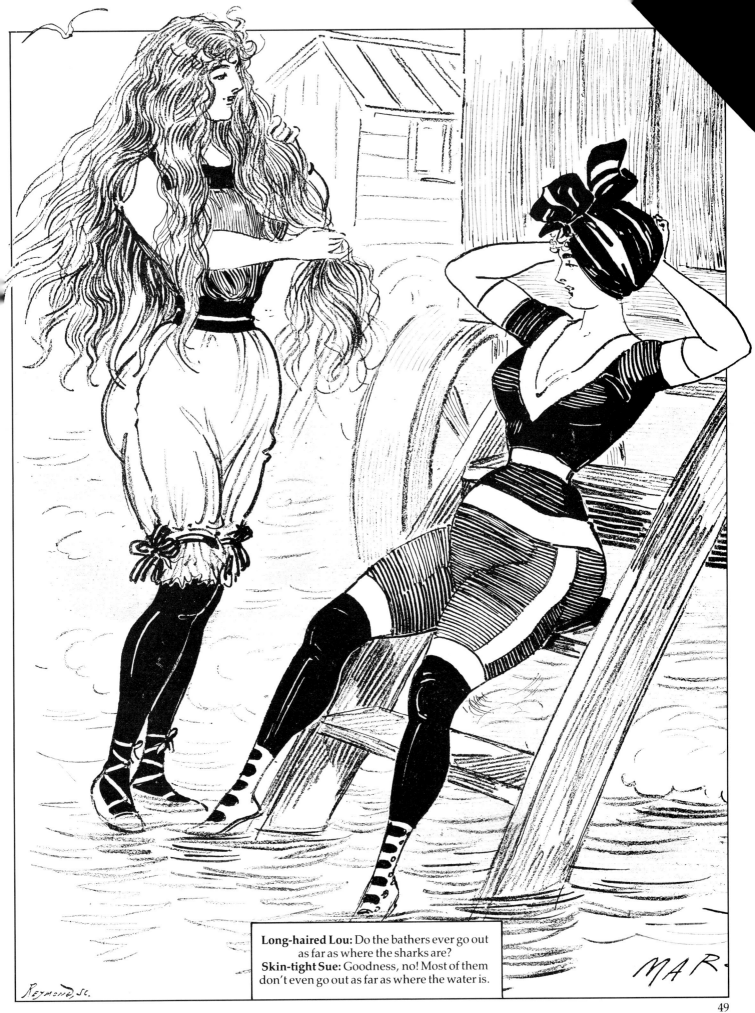

**Long-haired Lou:** Do the bathers ever go out as far as where the sharks are?
**Skin-tight Sue:** Goodness, no! Most of them don't even go out as far as where the water is.

49

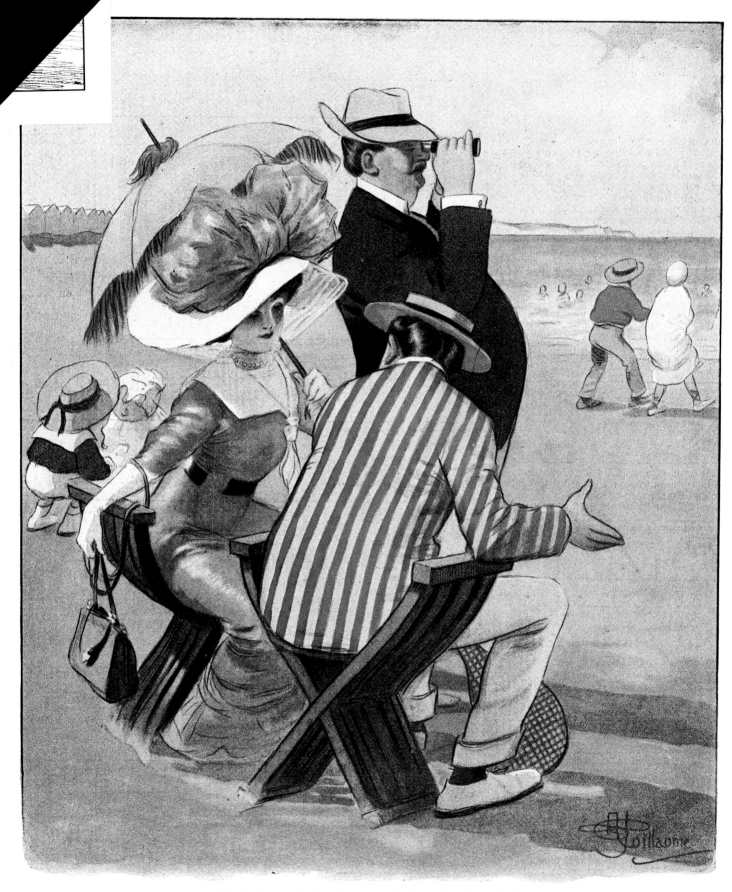

**He (sotto voce):** Does he ever talk about his first wife?
**She:** He used to – all the time. But not any more.
**He:** What stopped him?
**She:** I started talking about my next husband.

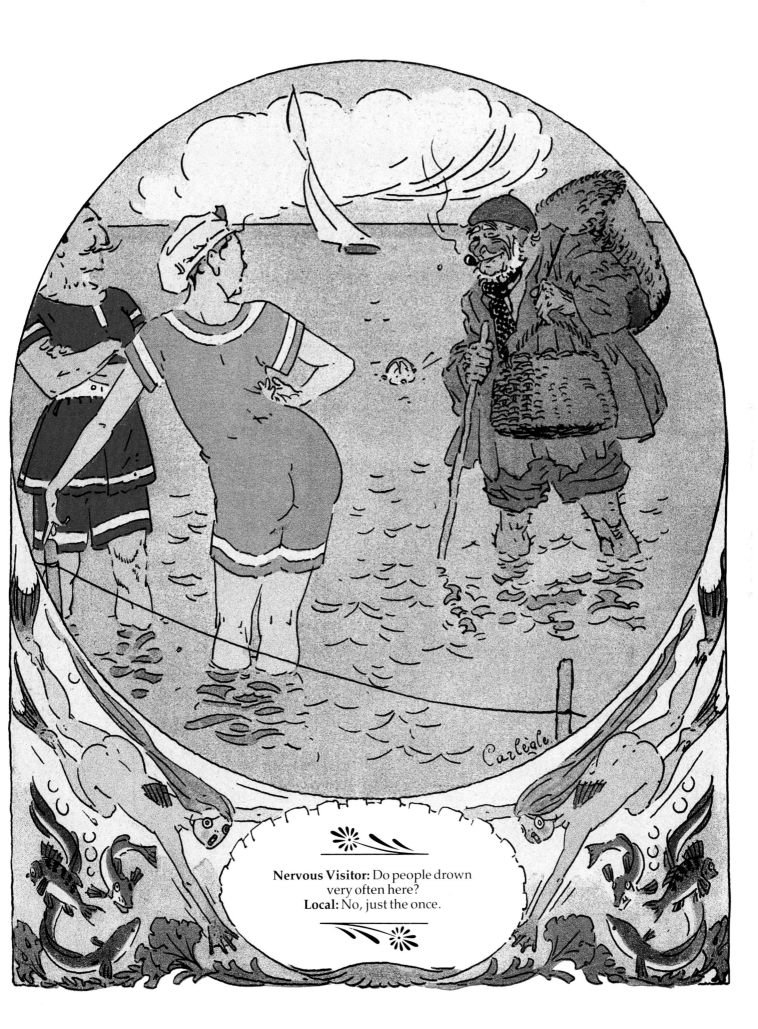

**Nervous Visitor:** Do people drown very often here?
**Local:** No, just the once.

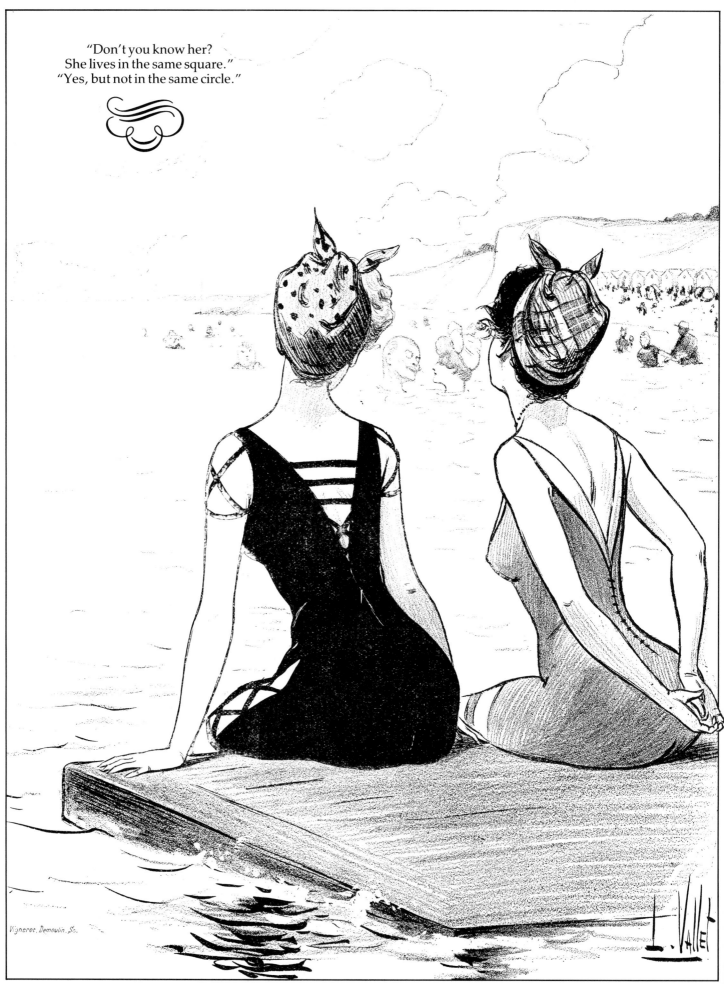

"Don't you know her?
She lives in the same square."
"Yes, but not in the same circle."

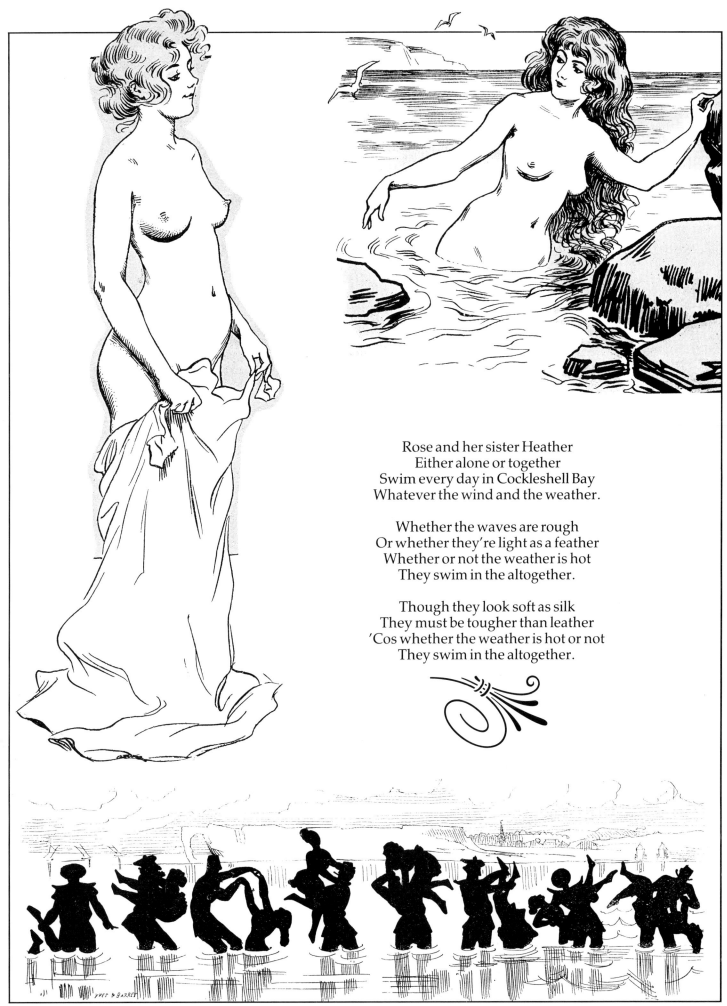

Rose and her sister Heather
Either alone or together
Swim every day in Cockleshell Bay
Whatever the wind and the weather.

Whether the waves are rough
Or whether they're light as a feather
Whether or not the weather is hot
They swim in the altogether.

Though they look soft as silk
They must be tougher than leather
'Cos whether the weather is hot or not
They swim in the altogether.

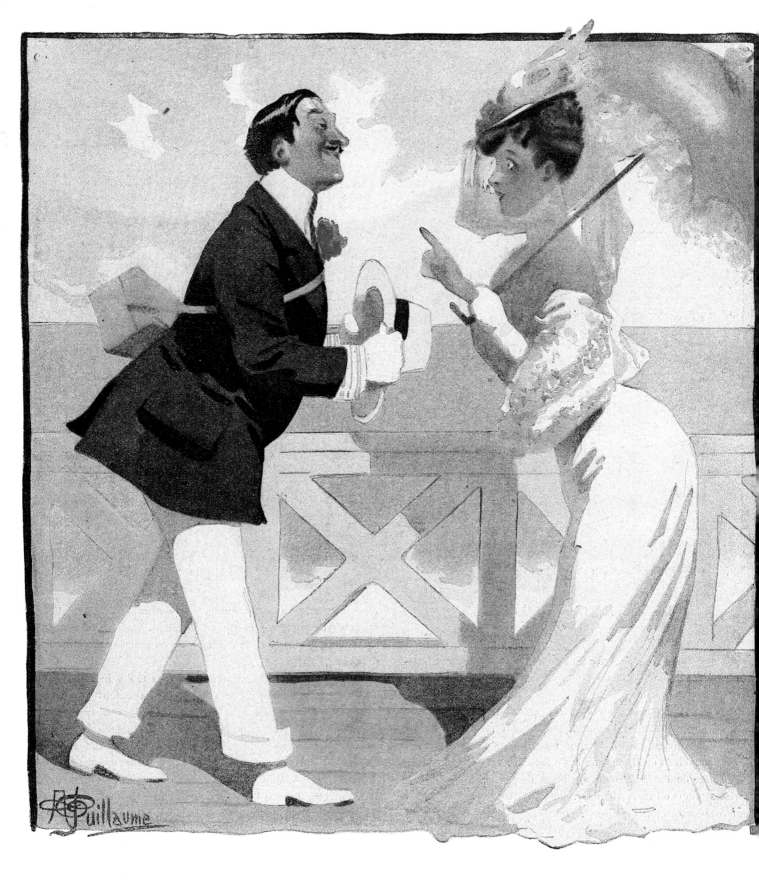

**He:** Dash it, Ermintrude, I love you. Let's get married, or something.
**She:** Let's get married, or *Nothing!*

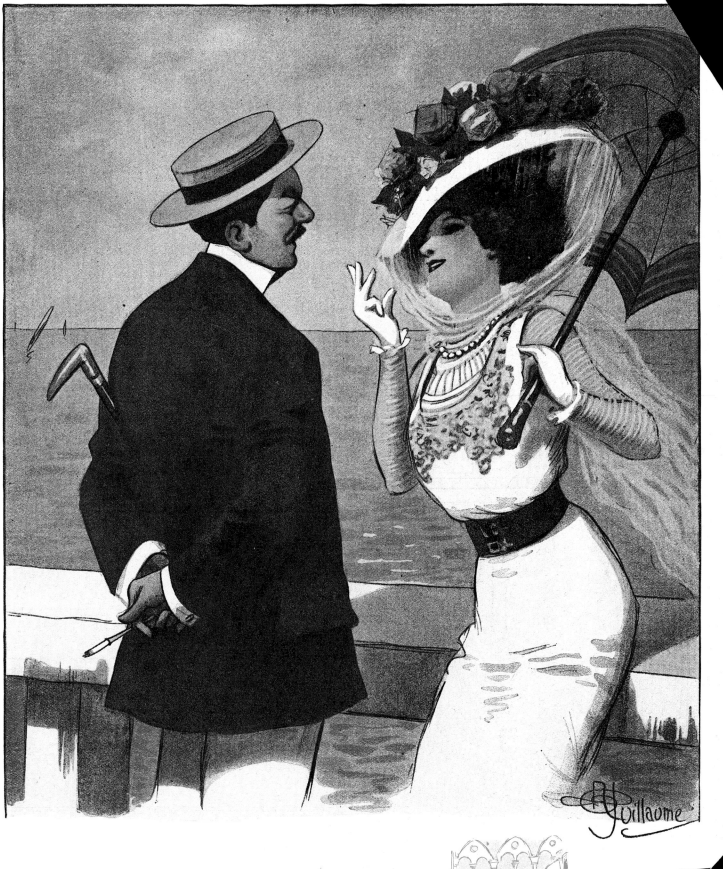

**She:** Let's go Dutch tonight.
**He:** How do you mean, Mam'selle?
**She:** You pay for the dinner and the drinks, and the rest of the evening will be on me.

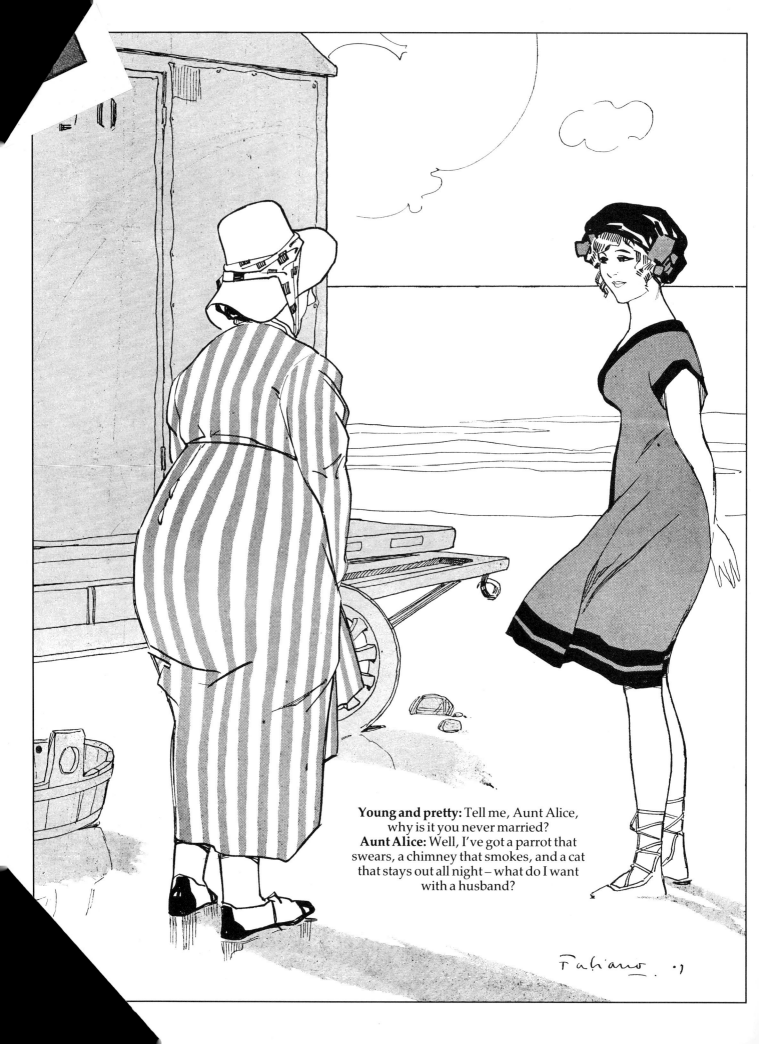

**Young and pretty:** Tell me, Aunt Alice, why is it you never married?
**Aunt Alice:** Well, I've got a parrot that swears, a chimney that smokes, and a cat that stays out all night – what do I want with a husband?

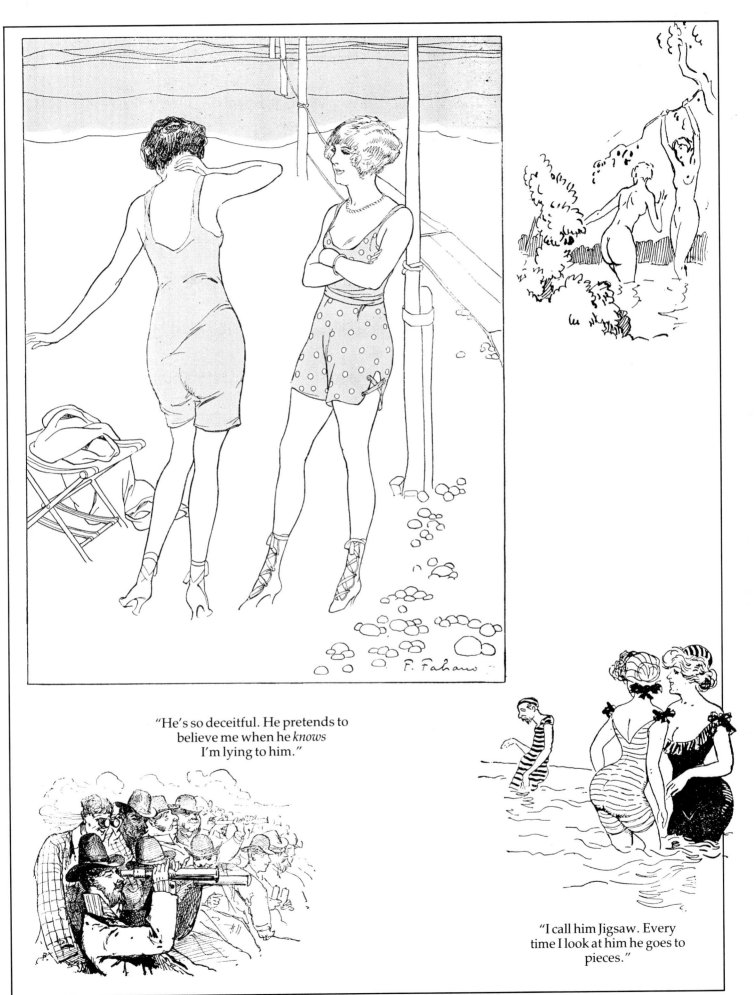

"He's so deceitful. He pretends to
believe me when he *knows*
I'm lying to him."

"I call him Jigsaw. Every
time I look at him he goes to
pieces."

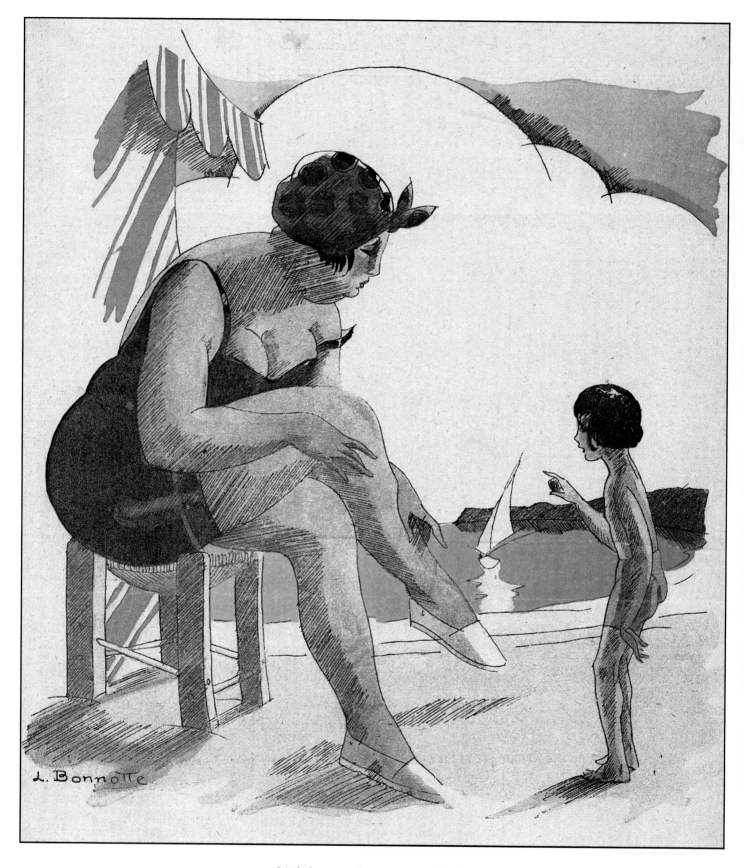

Little boys can be so very unkind,
Their questions so awfully blunt;
"Tell me, why have you got a behind behind
And another behind in front?"

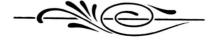

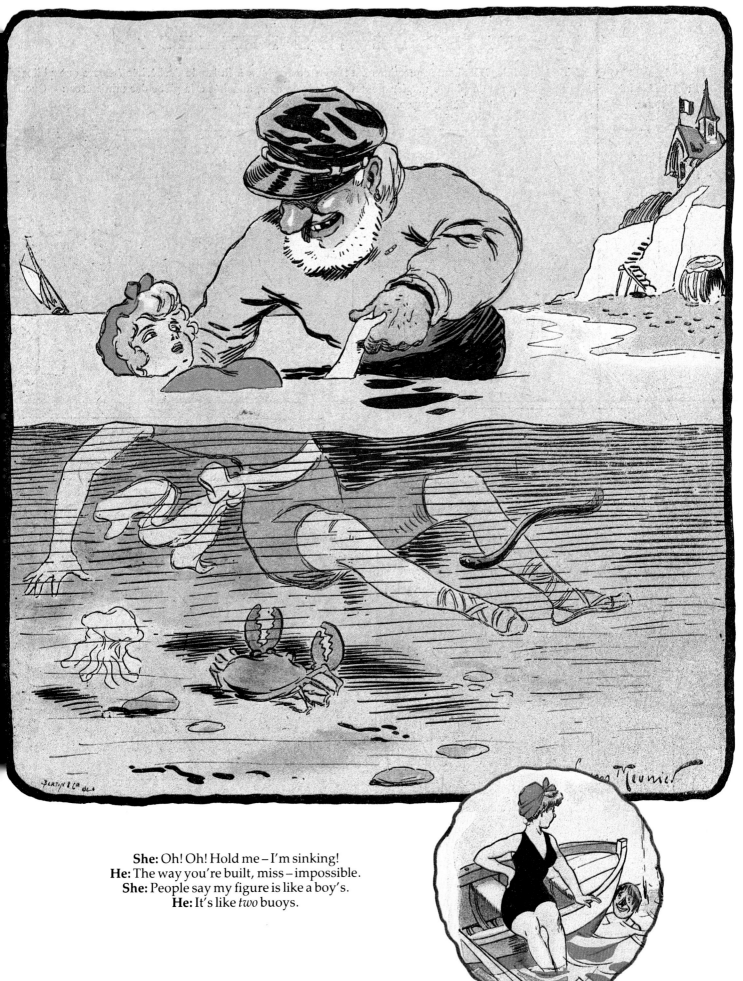

**She:** Oh! Oh! Hold me – I'm sinking!
**He:** The way you're built, miss – impossible.
**She:** People say my figure is like a boy's.
**He:** It's like *two* buoys.

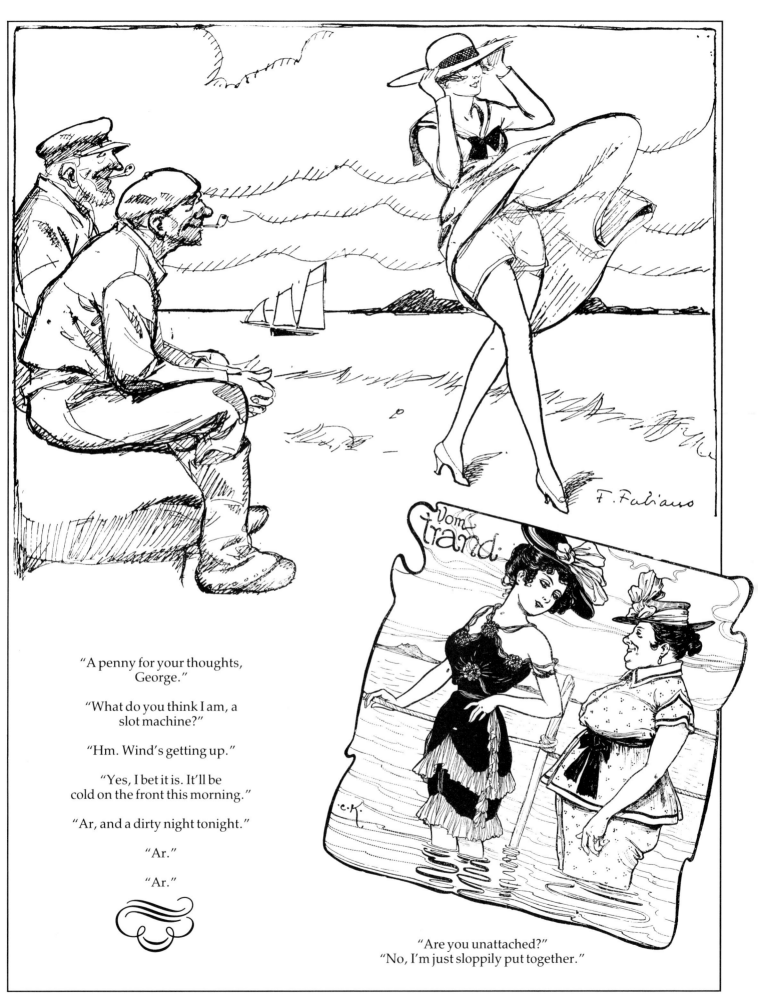

"A penny for your thoughts,
George."

"What do you think I am, a
slot machine?"

"Hm. Wind's getting up."

"Yes, I bet it is. It'll be
cold on the front this morning."

"Ar, and a dirty night tonight."

"Ar."

"Ar."

"Are you unattached?"
"No, I'm just sloppily put together."

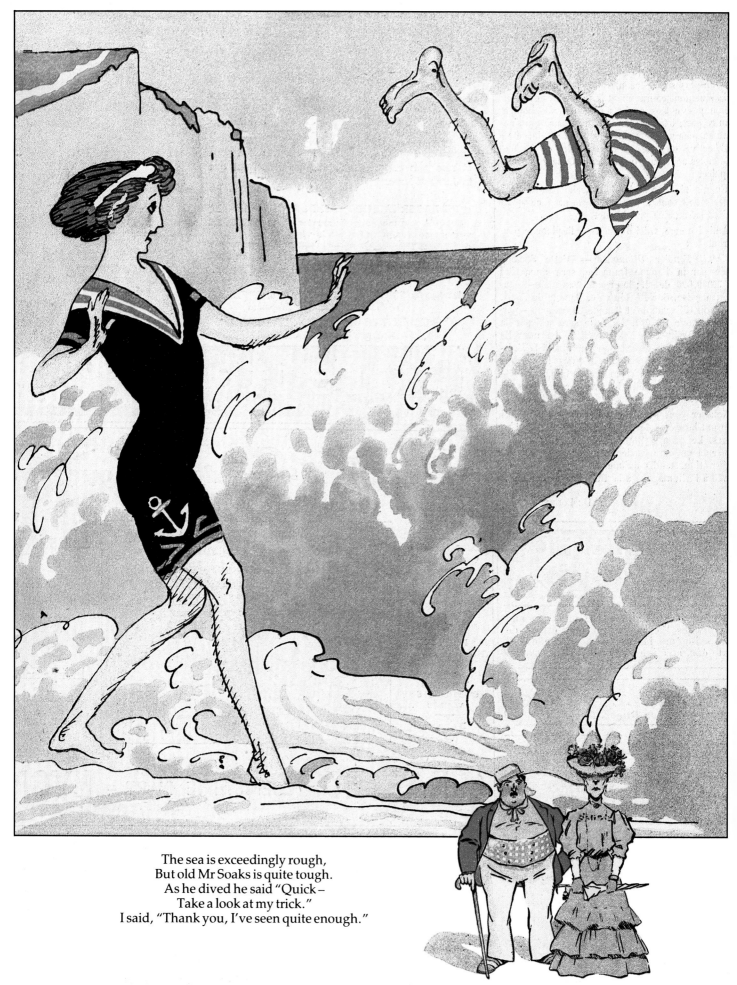

The sea is exceedingly rough,
But old Mr Soaks is quite tough.
As he dived he said "Quick –
Take a look at my trick."
I said, "Thank you, I've seen quite enough."

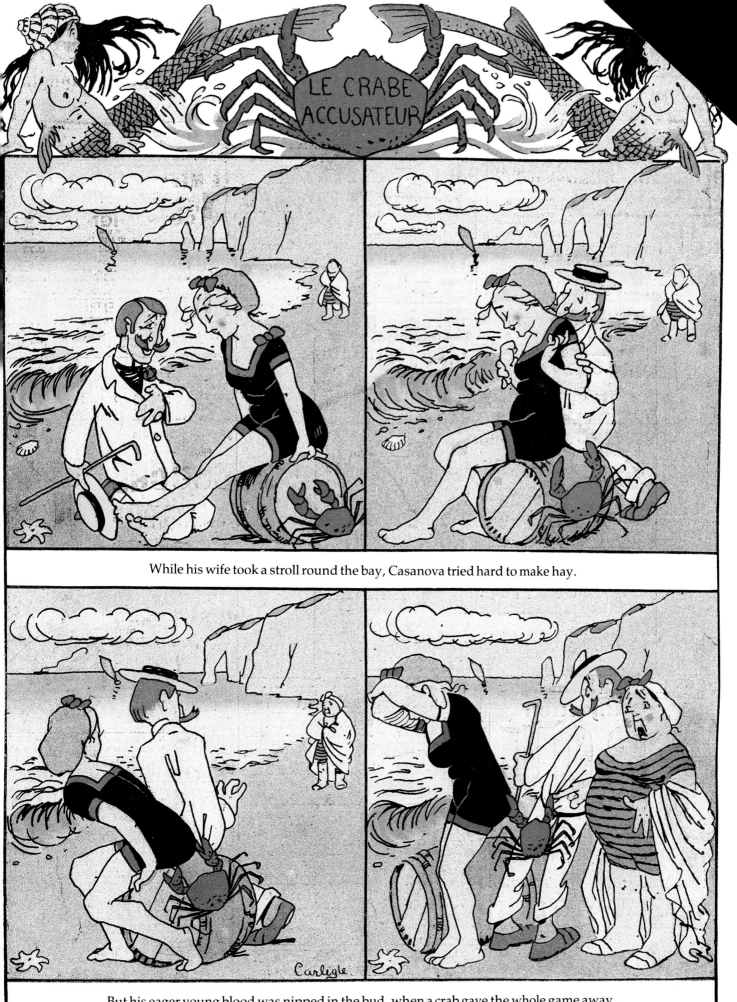

LE CRABE ACCUSATEUR

While his wife took a stroll round the bay, Casanova tried hard to make hay.

But his eager young blood was nipped in the bud, when a crab gave the whole game away.

Carlègle

# Ideal

I've found a girl so beautiful
She'll make the perfect spouse –
She's deaf and dumb and passionate
And owns a public house.

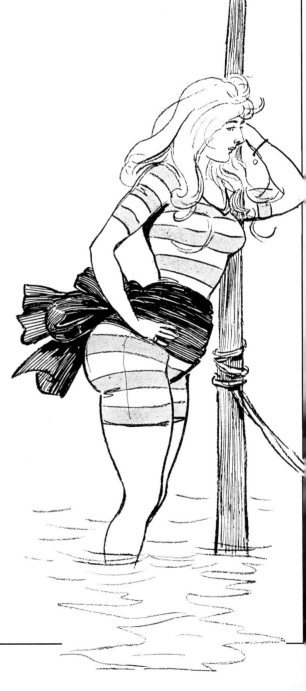

## Offers

Girls who offer themselves as a wife
Will live in drudgery all their life;
Girls who offer wise advice
Won't be asked by the same man twice.
But girls who offer no resistance
Lead the very best existence.

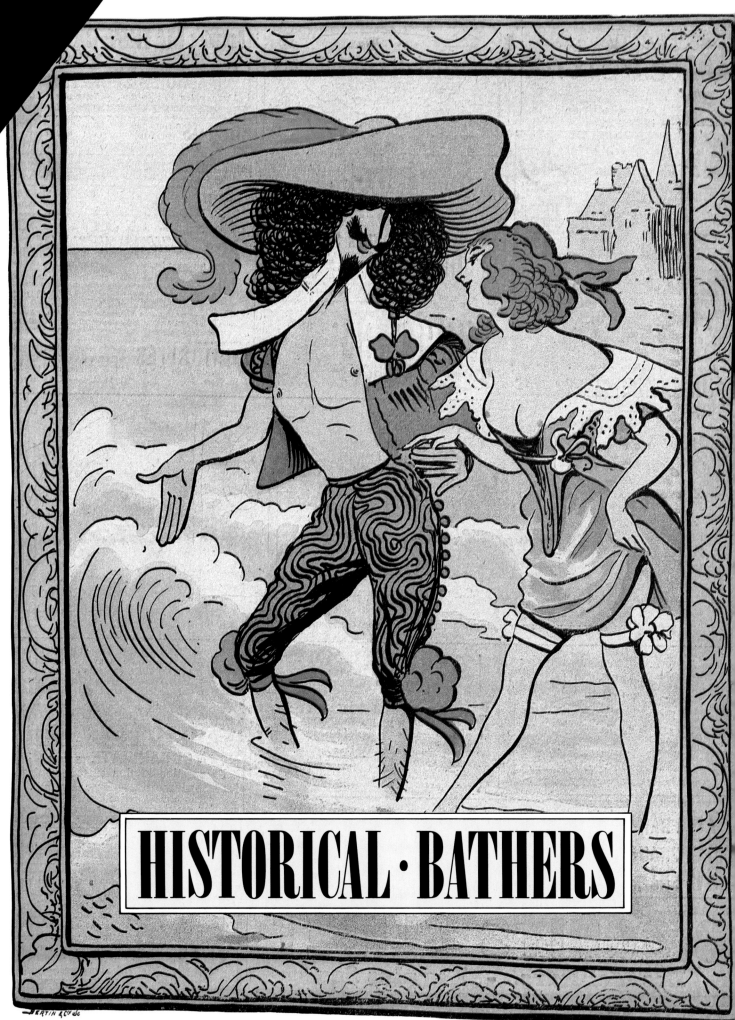

HISTORICAL · BATHERS

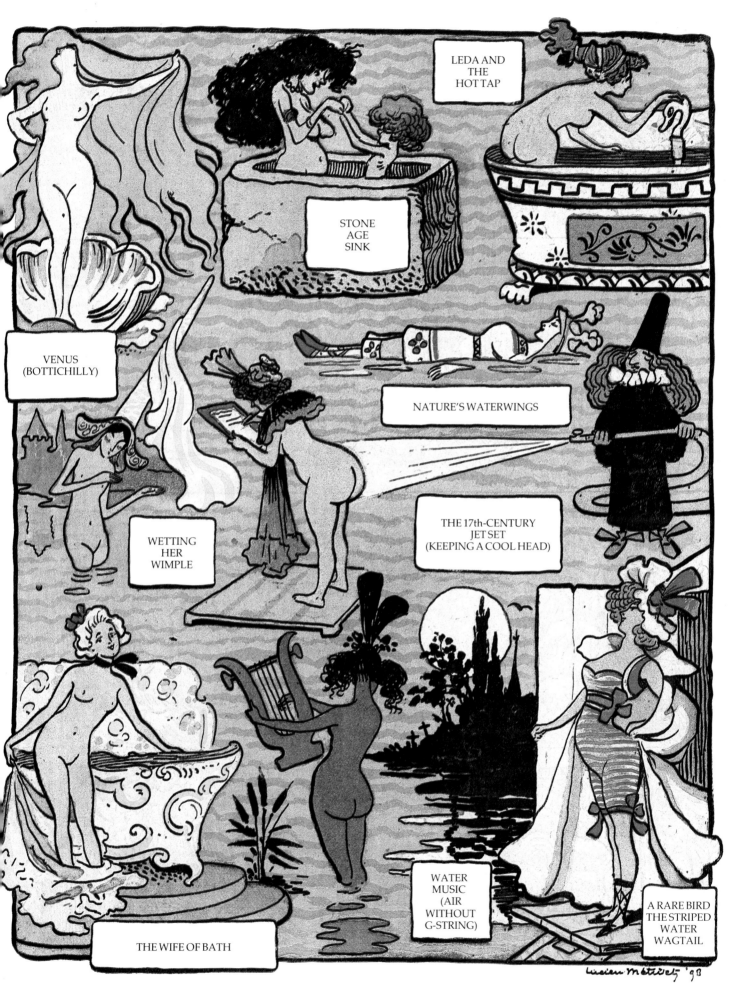

VENUS
(BOTTICHILLY)

LEDA AND
THE
HOT TAP

STONE
AGE
SINK

NATURE'S WATERWINGS

WETTING
HER
WIMPLE

THE 17th-CENTURY
JET SET
(KEEPING A COOL HEAD)

THE WIFE OF BATH

WATER
MUSIC
(AIR
WITHOUT
G-STRING)

A RARE BIRD
THE STRIPED
WATER
WAGTAIL

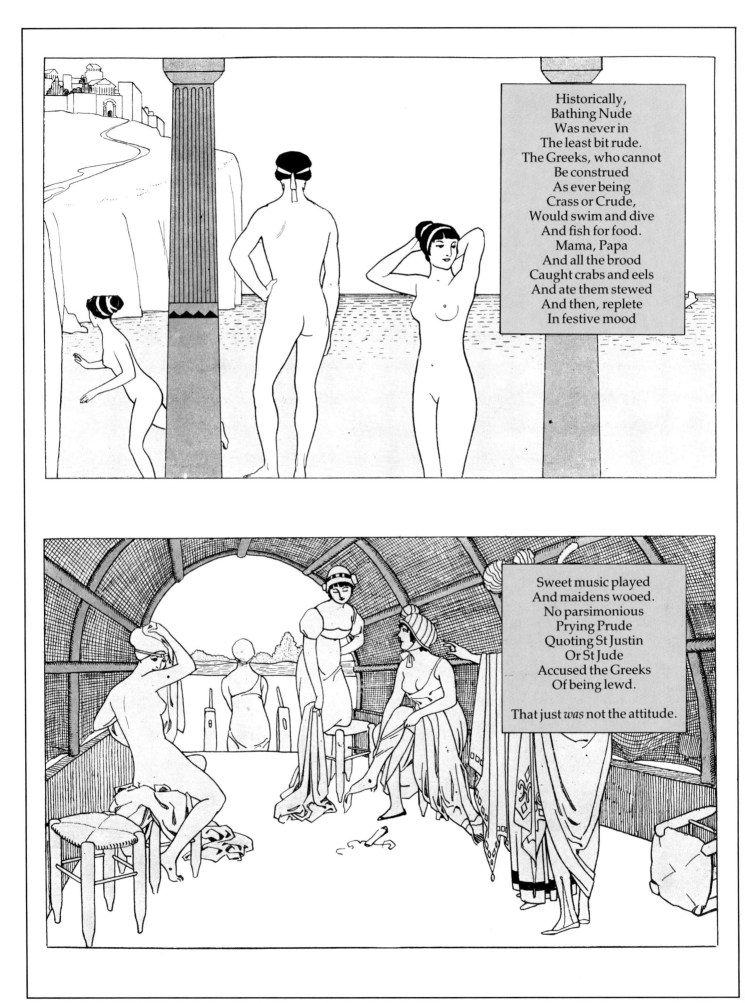

Historically,
Bathing Nude
Was never in
The least bit rude.
The Greeks, who cannot
Be construed
As ever being
Crass or Crude,
Would swim and dive
And fish for food.
Mama, Papa
And all the brood
Caught crabs and eels
And ate them stewed
And then, replete
In festive mood

Sweet music played
And maidens wooed.
No parsimonious
Prying Prude
Quoting St Justin
Or St Jude
Accused the Greeks
Of being lewd.

That just *was* not the attitude.

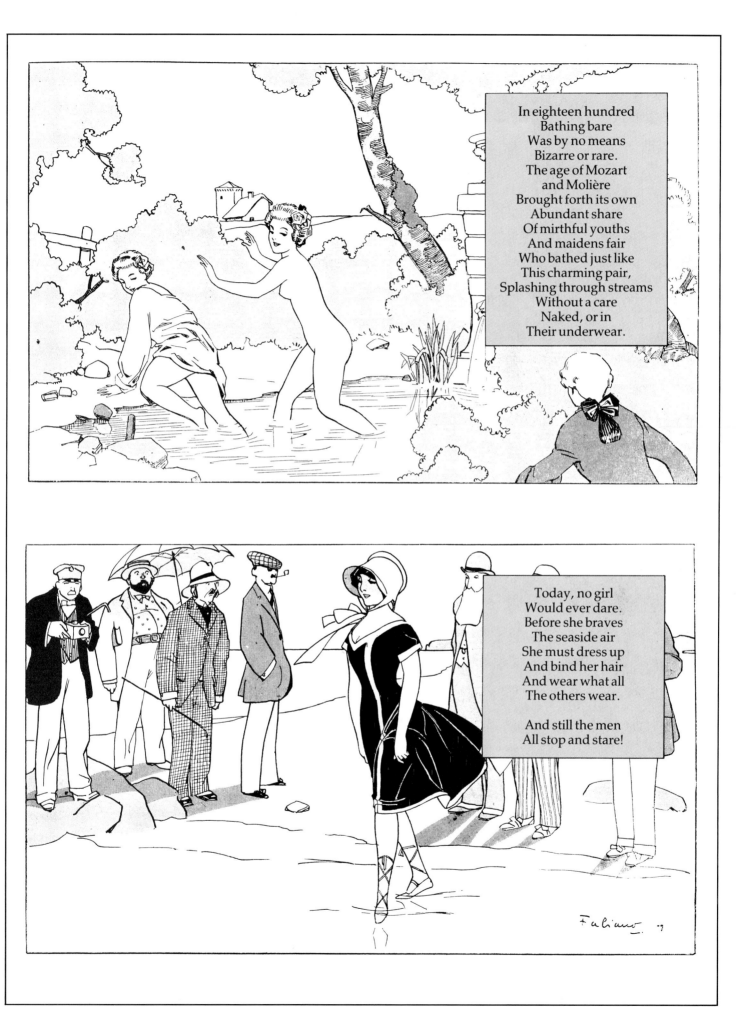

In eighteen hundred
Bathing bare
Was by no means
Bizarre or rare.
The age of Mozart
and Molière
Brought forth its own
Abundant share
Of mirthful youths
And maidens fair
Who bathed just like
This charming pair,
Splashing through streams
Without a care
Naked, or in
Their underwear.

Today, no girl
Would ever dare.
Before she braves
The seaside air
She must dress up
And bind her hair
And wear what all
The others wear.

And still the men
All stop and stare!

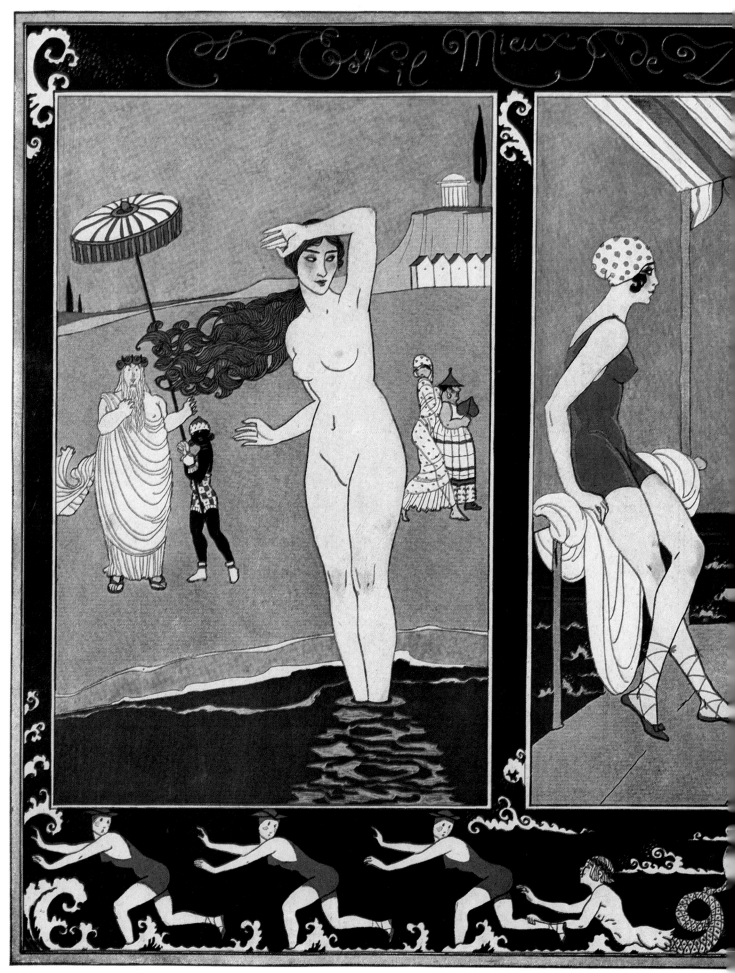

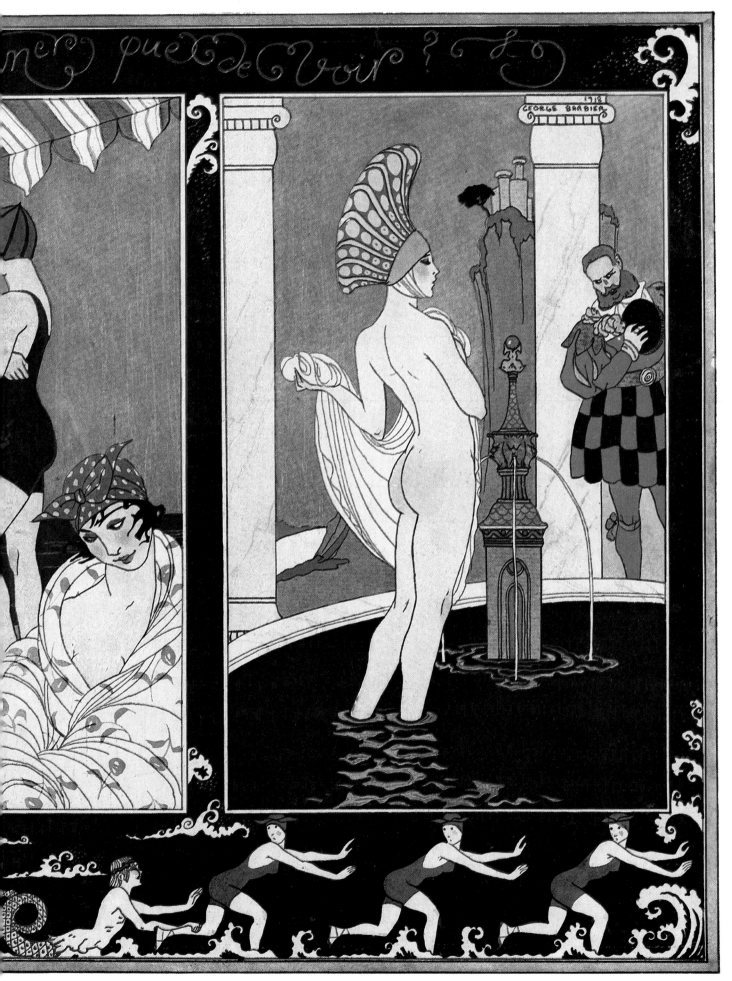

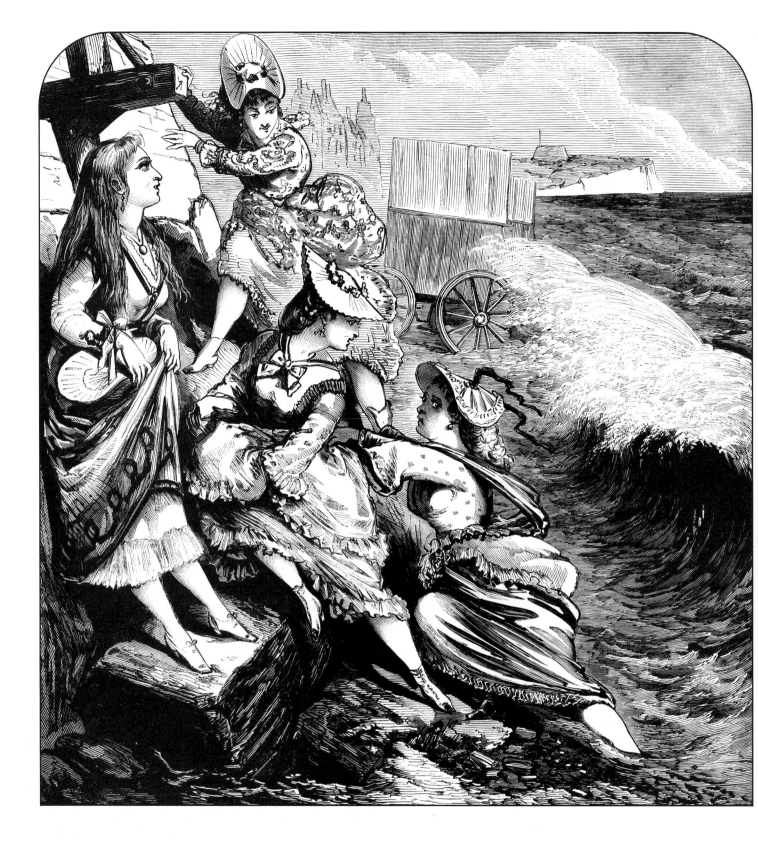

Historically, the sea was regarded as being much more treacherous and
unfriendly than today. People treated it with more respect, as a cold
adversary rather than a warm friend. They ventured rather than dashed into it.
A sensational weekly newspaper of the 1870s with the unlikely
title of "The Days' Doings" (see facsimile of original front page heading),
produced some rather revealing wood engravings of young girls at the mercy of Father Neptune.

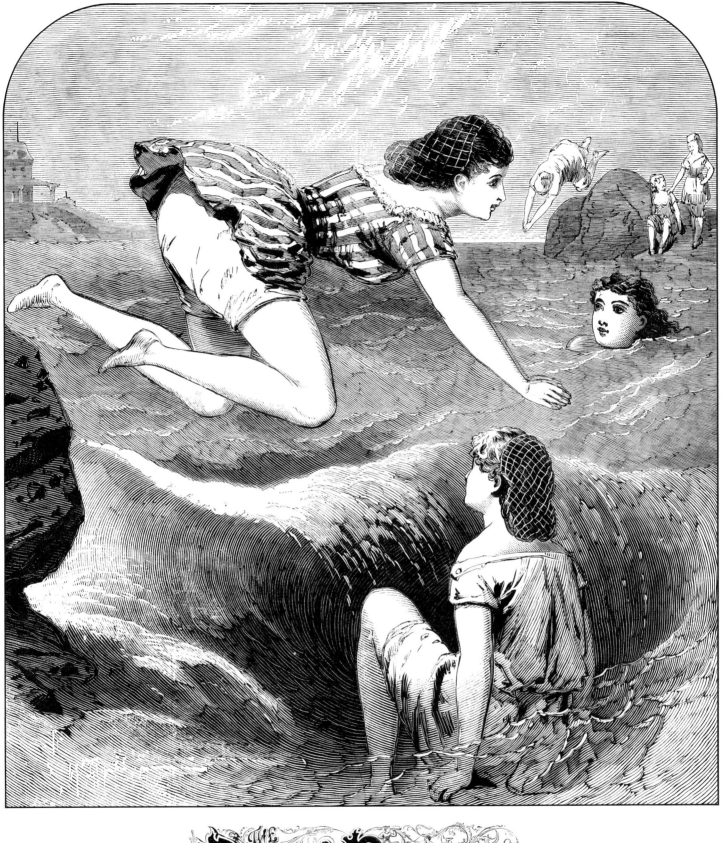

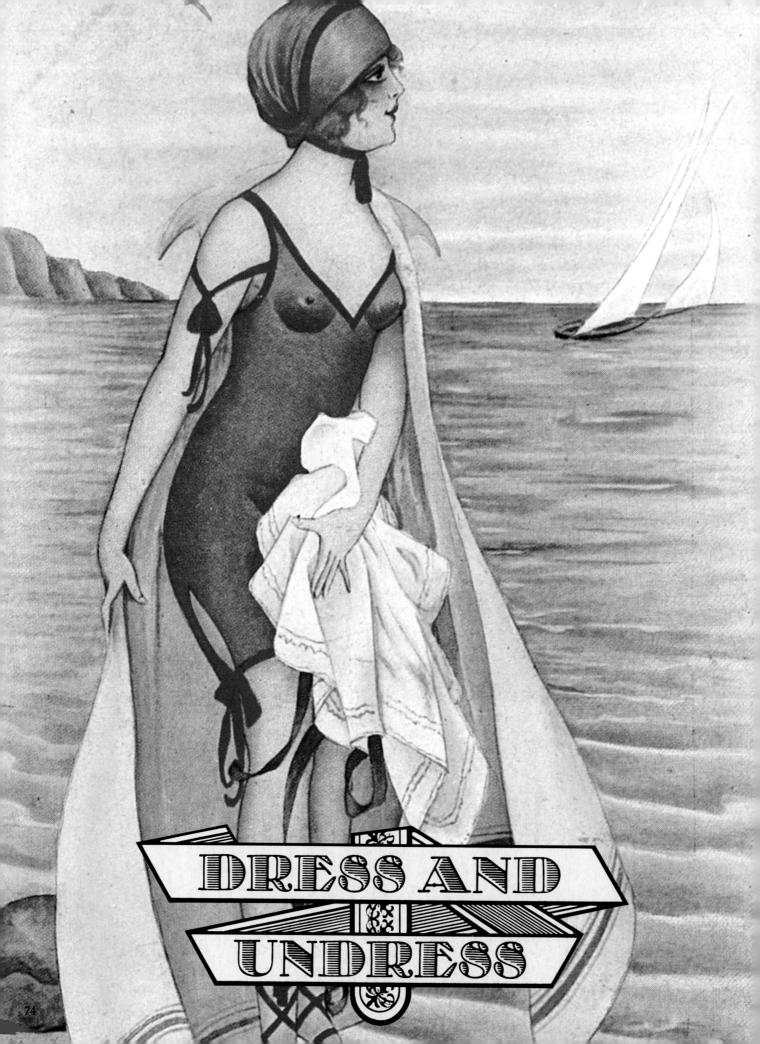

DRESS AND UNDRESS

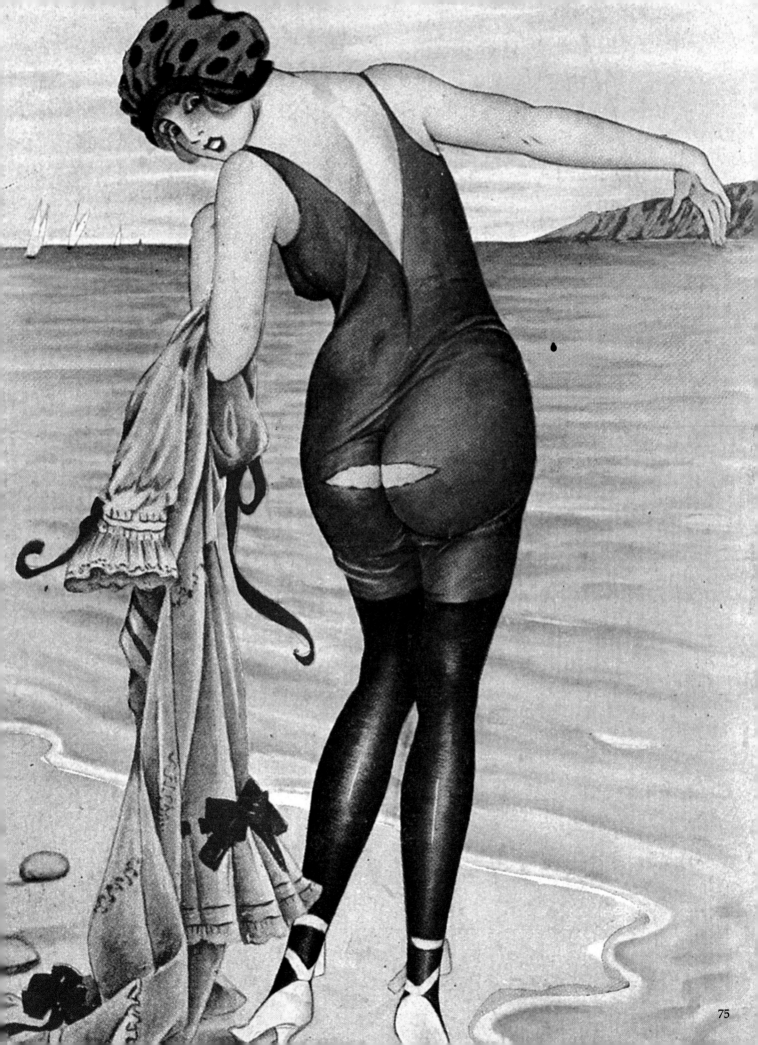

# DRESS AND UNDRESS

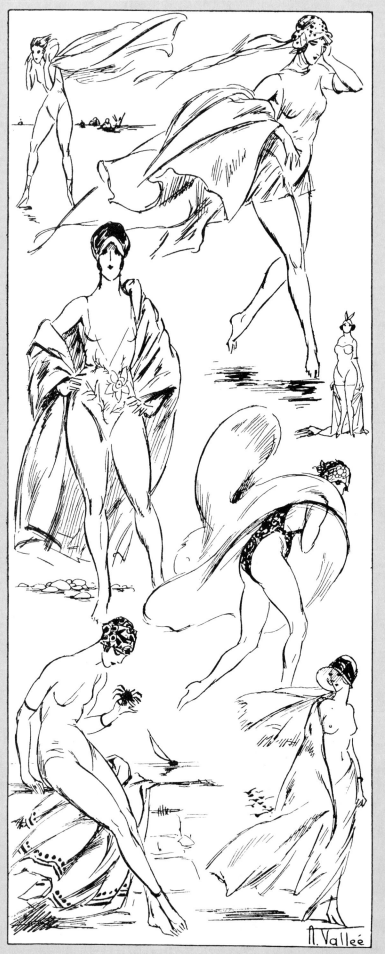

As far as the ladies are concerned, (and insofar as we are concerned with the ladies) at the seaside, it's not what you do that matters, it's what you do it *in*.

You can plunge in, plod in, paddle in puddles or simply peripatate on the perimeter, no-one cares two hoots. What matters (and I speak for all red-blooded males, and quite a few blue-blooded ones as well, I shouldn't wonder) is what delights you have decided to reveal or withhold on this particular morning.

When a man says to a girl, "What a pretty bathing costume", what he really means is, "How pretty you look in that bathing costume." Because it has to be said that the same suit will not draw many glances when draped over the back of a deckchair.

And, of course, each year they get smaller. Two men were heard on the promenade: "My wife's very clever. She made my tie out of one of her old bathing costumes." "Really? Wait till you see the bathing costume my wife made out of one of my old ties."

A. Vallée

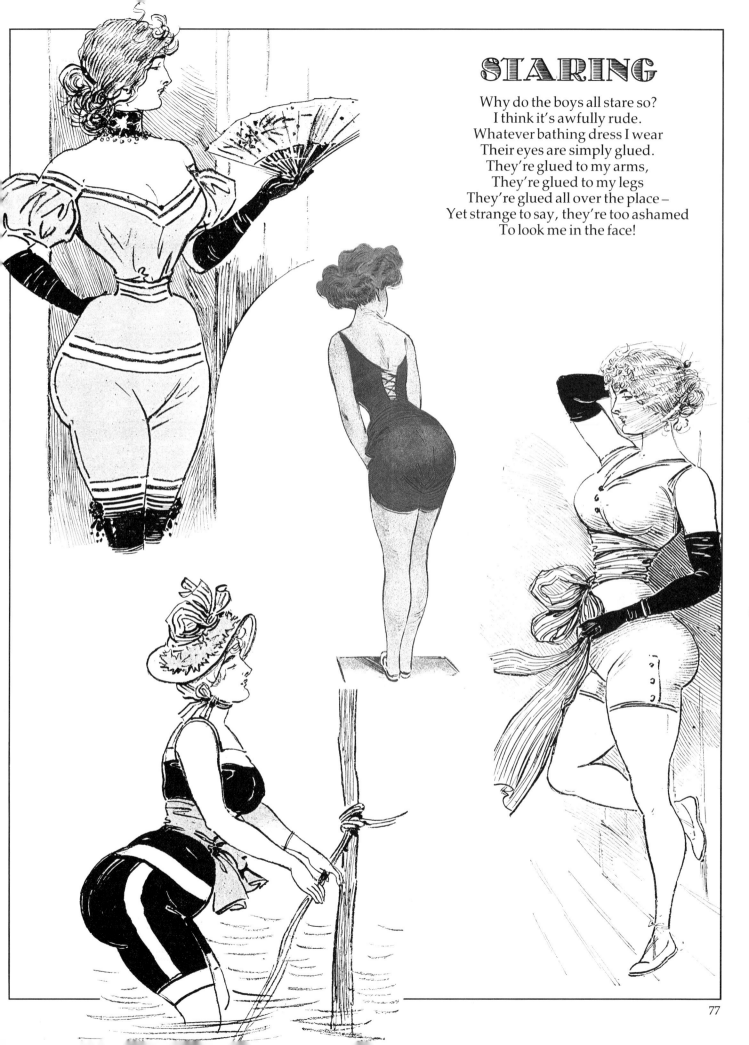

# STARING

Why do the boys all stare so?
I think it's awfully rude.
Whatever bathing dress I wear
Their eyes are simply glued.
They're glued to my arms,
They're glued to my legs
They're glued all over the place –
Yet strange to say, they're too ashamed
To look me in the face!

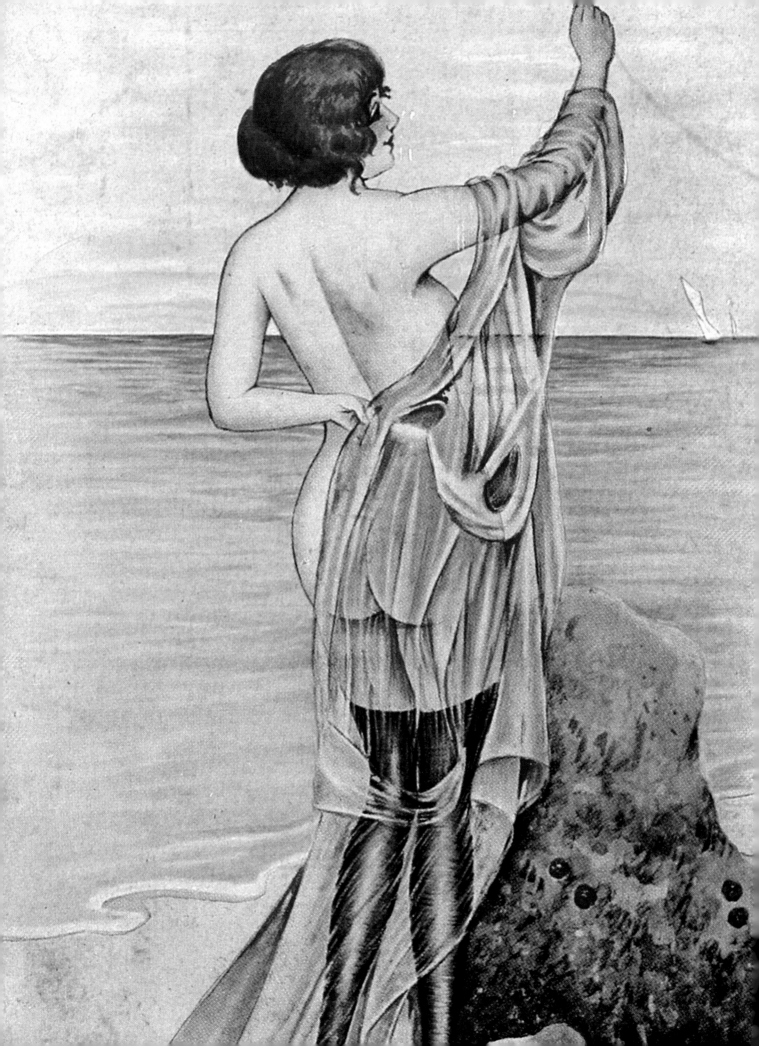

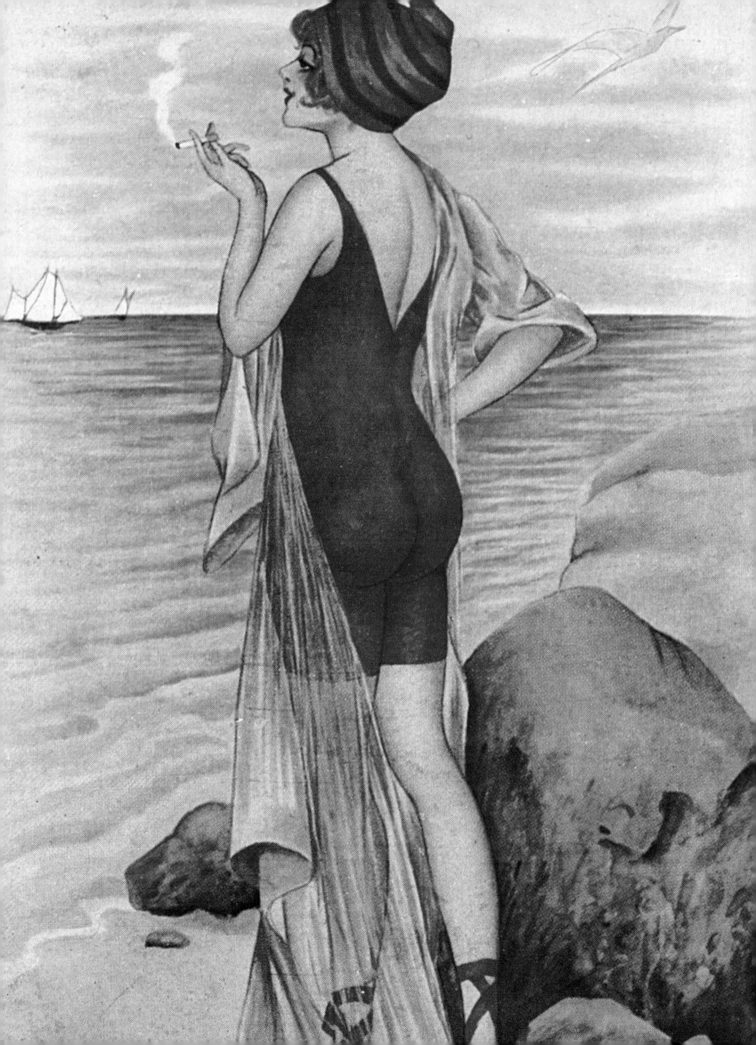

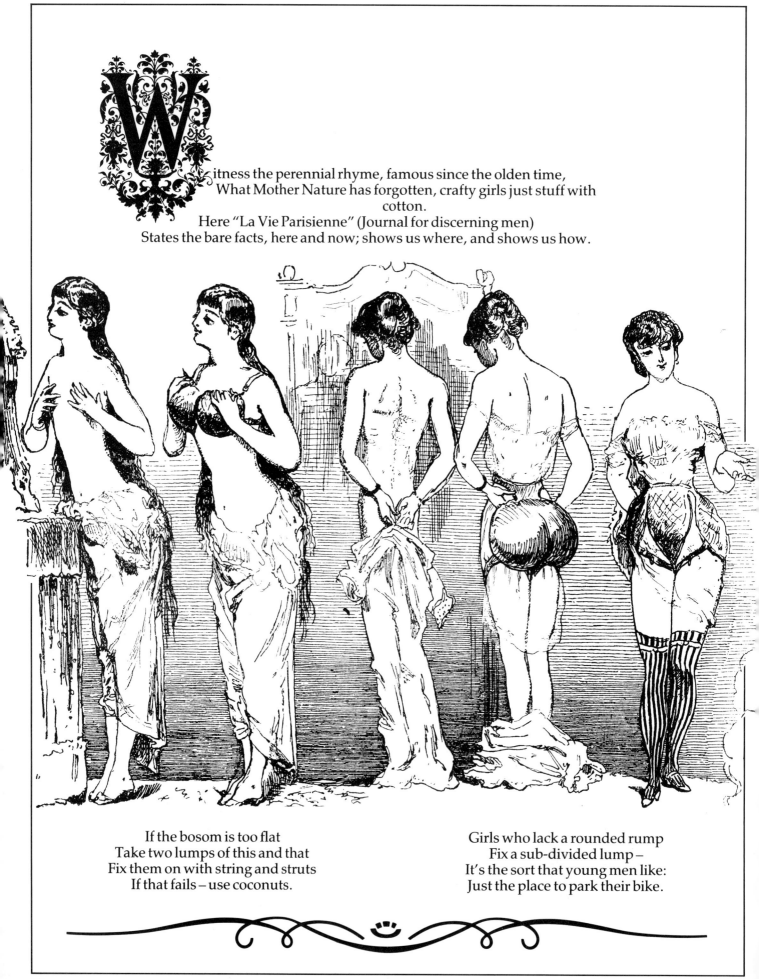

**W**itness the perennial rhyme, famous since the olden time,
What Mother Nature has forgotten, crafty girls just stuff with
cotton.
Here "La Vie Parisienne" (Journal for discerning men)
States the bare facts, here and now; shows us where, and shows us how.

If the bosom is too flat
Take two lumps of this and that
Fix them on with string and struts
If that fails – use coconuts.

Girls who lack a rounded rump
Fix a sub-divided lump –
It's the sort that young men like:
Just the place to park their bike.

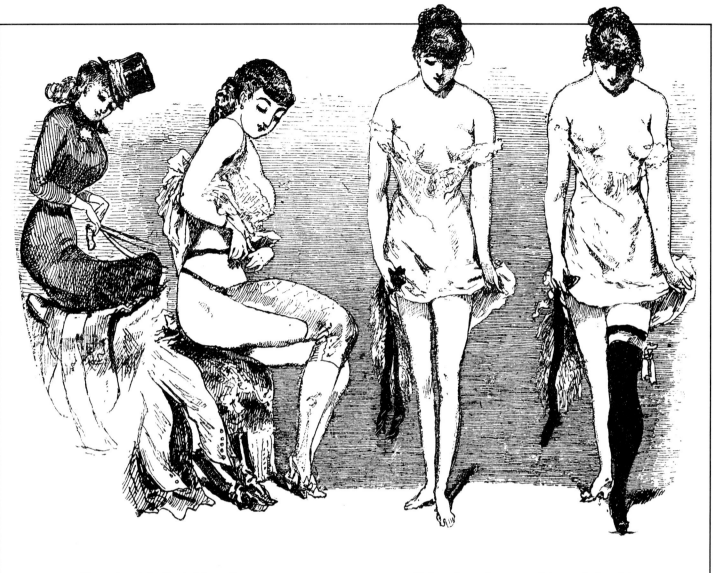

County girls that ride, of course
Wear more harness than the horse.
Since she lacks those strapping thighs
Strapped-*on* thighs instead she tries.

Girls whose legs are thin and shocking
Wear no ordinary stocking;
No good doing things by halves
Fool them all with padded calves!

THESE DECEPTIONS PROVE A BOON – THAT IS, UNTIL THE HONEYMOON!
PICTURE THE DISILLUSIONED GROOM, HIS WIFE ALL LITTERED ROUND THE ROOM!

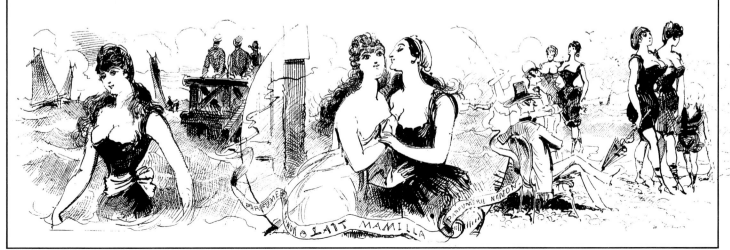

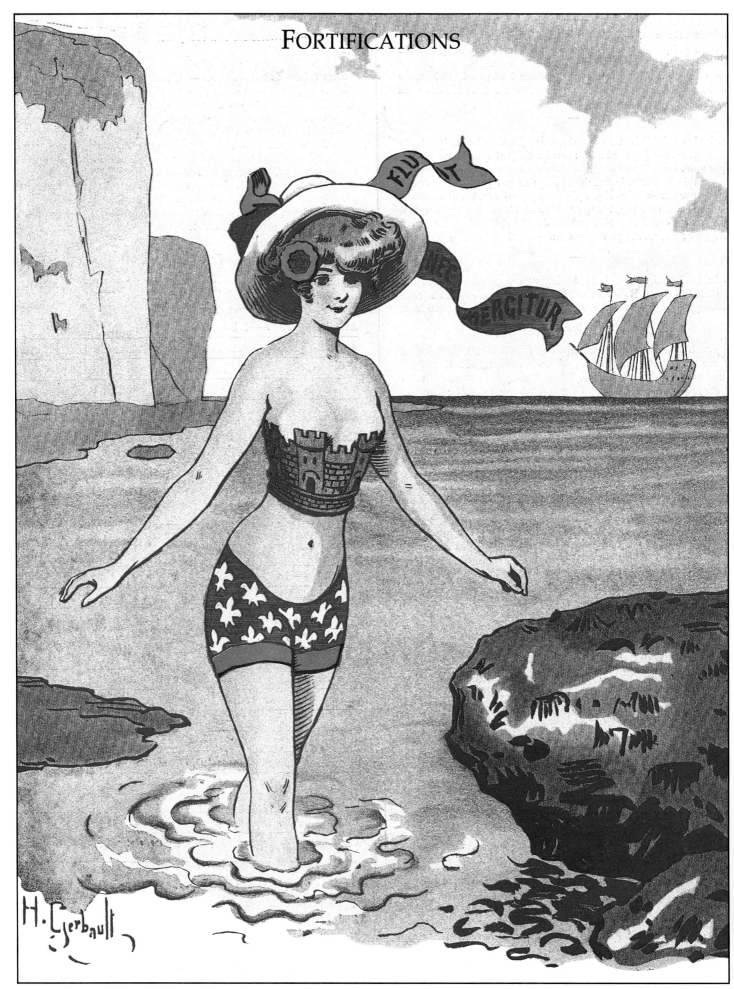

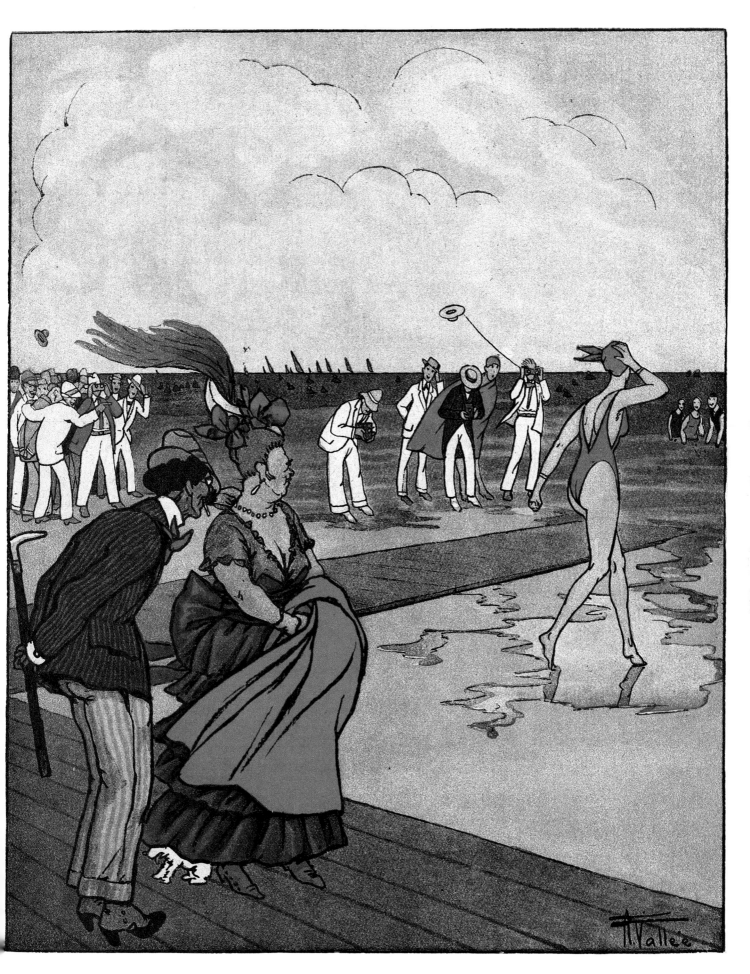

**Mrs Rickenbacker:** Really! Some of these costumes are no bigger than postage stamps!
**Groucho Marx's grandpa:** One thing is certain – they'll always deliver the male.

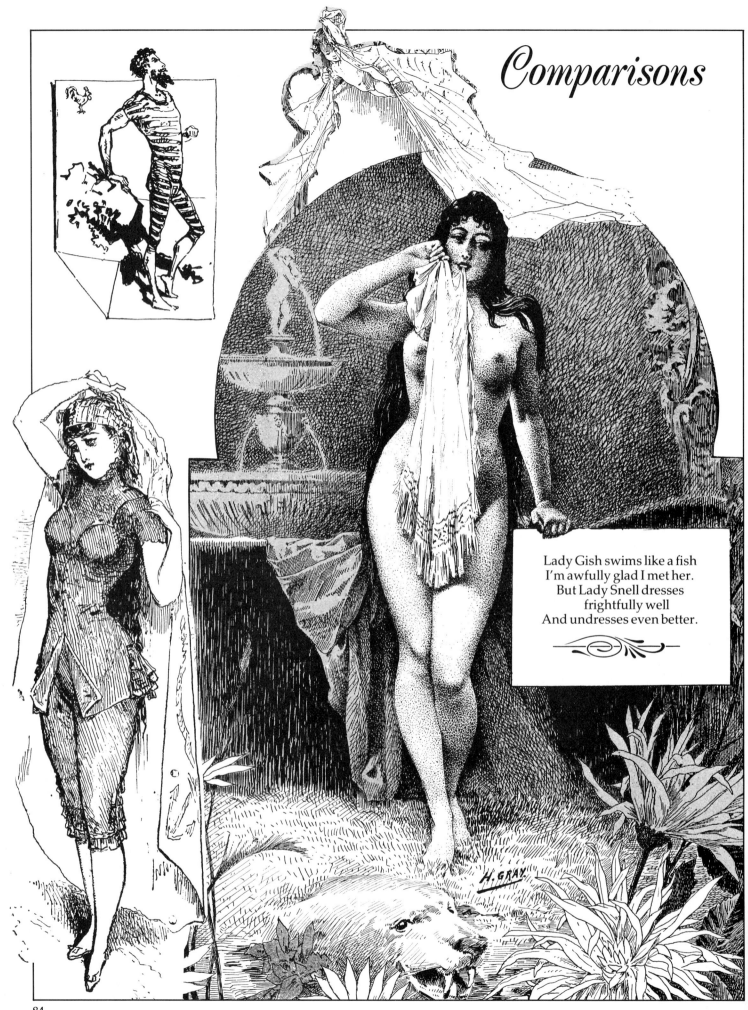

# Comparisons

Lady Gish swims like a fish
I'm awfully glad I met her.
But Lady Snell dresses
frightfully well
And undresses even better.

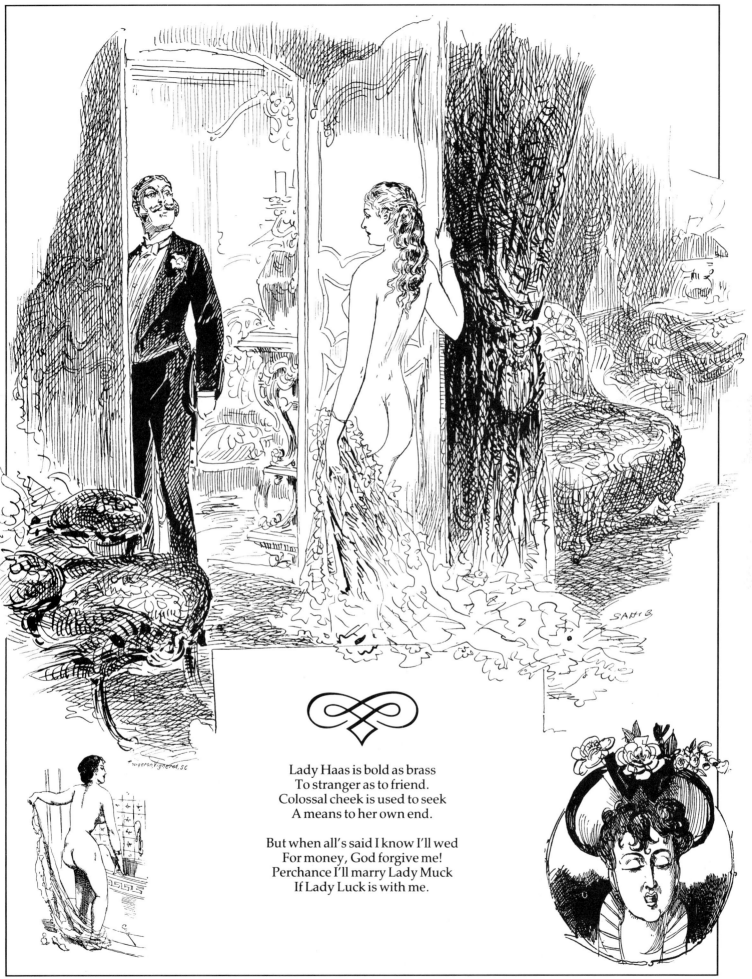

Lady Haas is bold as brass
To stranger as to friend.
Colossal cheek is used to seek
A means to her own end.

But when all's said I know I'll wed
For money, God forgive me!
Perchance I'll marry Lady Muck
If Lady Luck is with me.

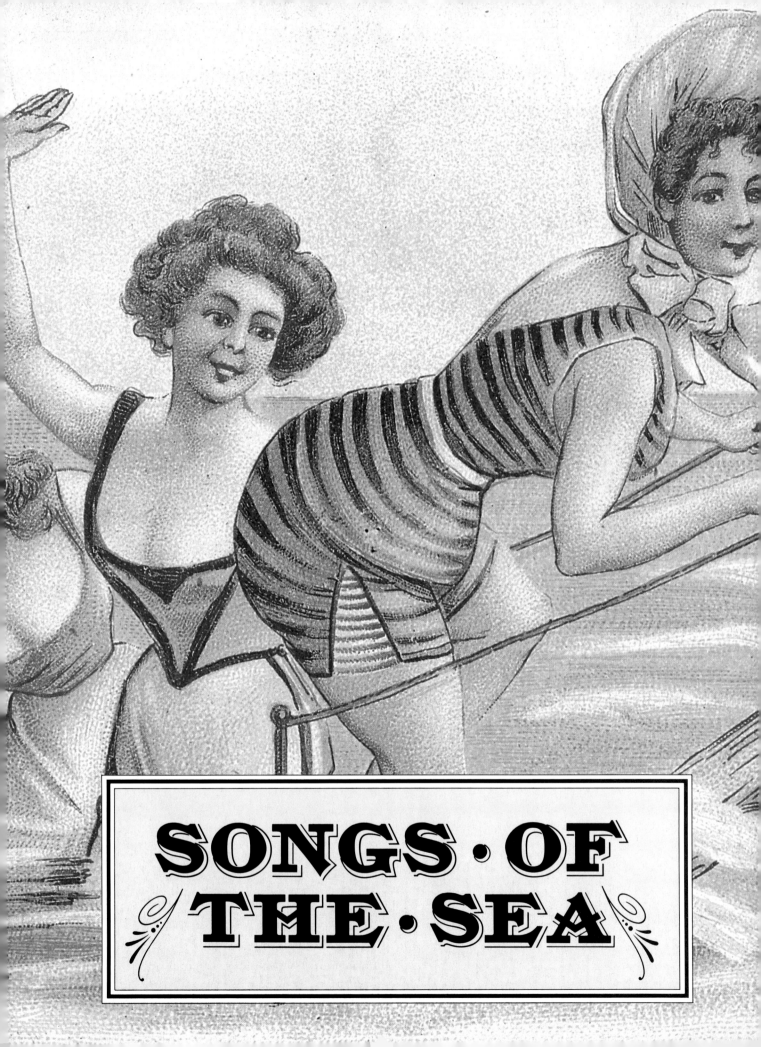

SONGS · OF
THE · SEA

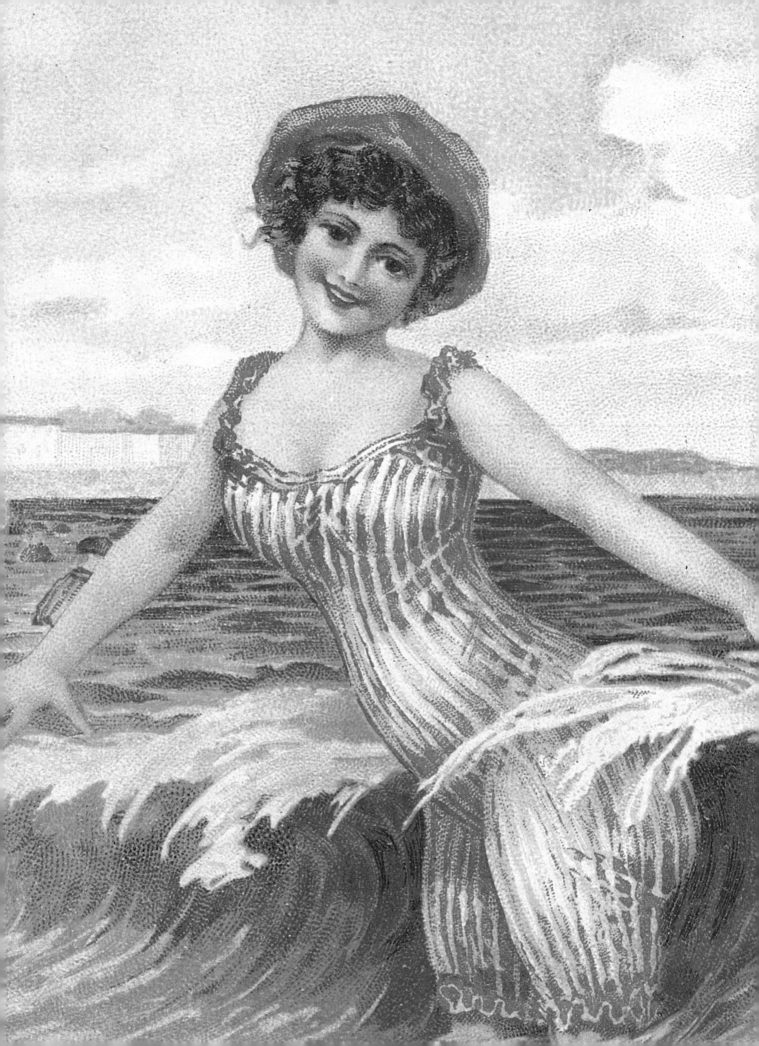

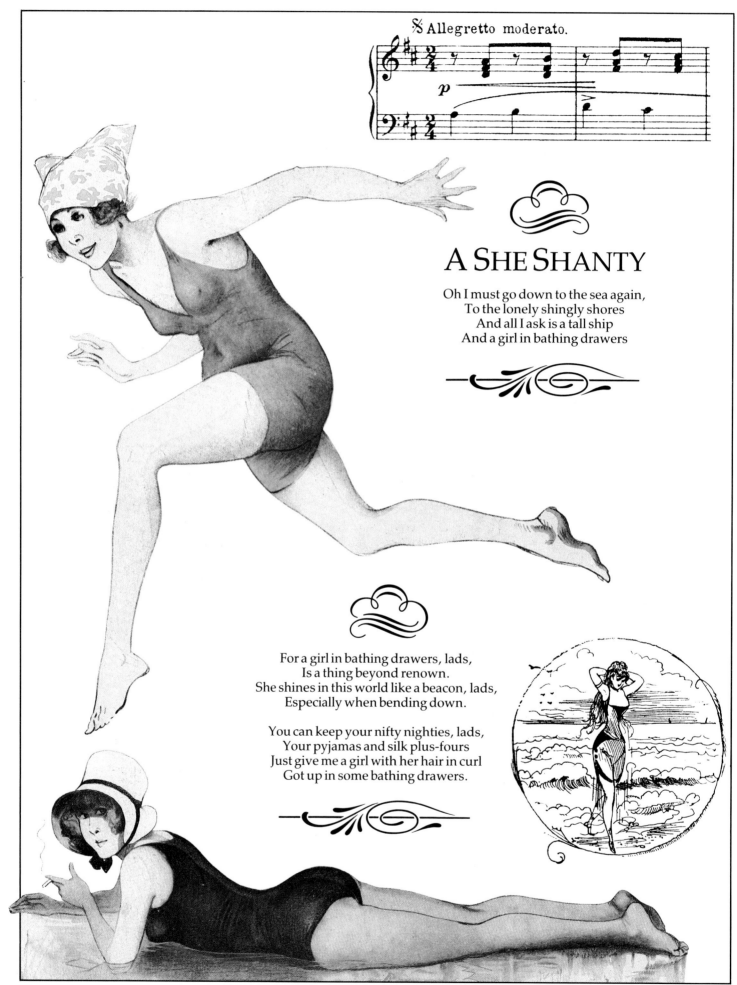

## A SHE SHANTY

Oh I must go down to the sea again,
To the lonely shingly shores
And all I ask is a tall ship
And a girl in bathing drawers

For a girl in bathing drawers, lads,
Is a thing beyond renown.
She shines in this world like a beacon, lads,
Especially when bending down.

You can keep your nifty nighties, lads,
Your pyjamas and silk plus-fours
Just give me a girl with her hair in curl
Got up in some bathing drawers.

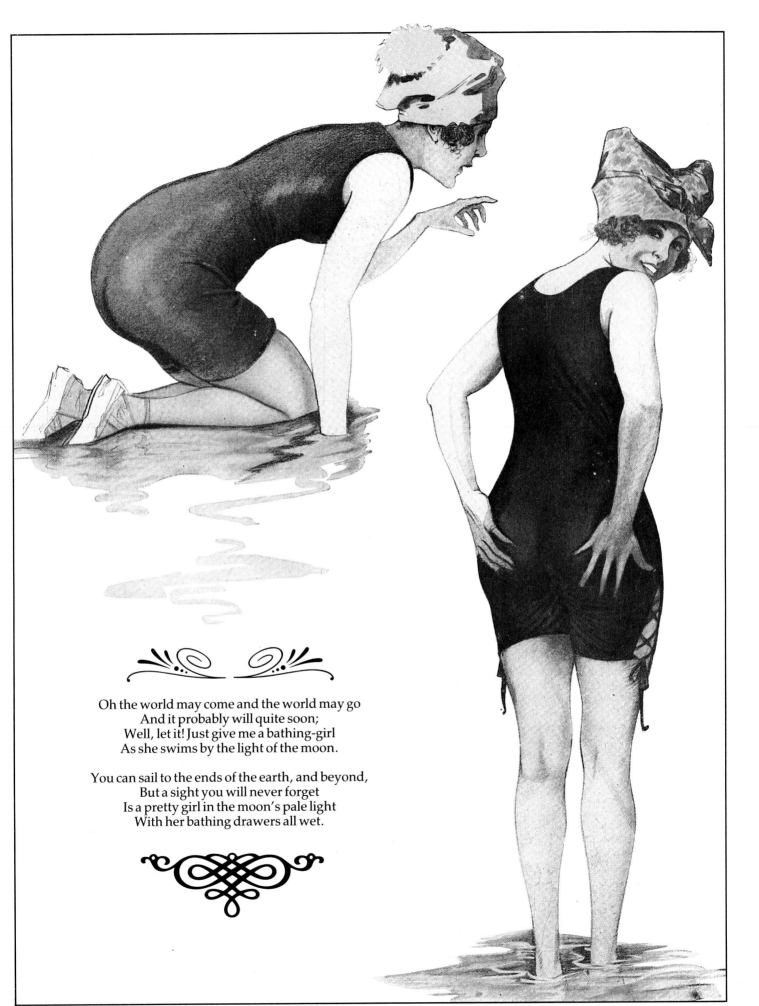

Oh the world may come and the world may go
And it probably will quite soon;
Well, let it! Just give me a bathing-girl
As she swims by the light of the moon.

You can sail to the ends of the earth, and beyond,
But a sight you will never forget
Is a pretty girl in the moon's pale light
With her bathing drawers all wet.

# "BY·THE·SEA"

(AS SUNG BY THE GREAT HARRY POLLARD)

### VERSE ONE

By the sea – on the sand
Down among the bathers and the band
Boys of all ages with a light in their eye
Watching all the shapes and sizes going by
By the sea, on the sand
A girl can get her cheeks severely tanned
The girls down by the jetty, they don't lie on their backs
They all lie on their tummies, like performing seals in packs
Trying to catch the fishermen and waiting for the smacks
By the Sea, on the Shore, on the Sand.

### VERSE TWO

By the sea – on the beach
Not every girl's a melon or a peach,
Here comes a lady who is showing too much,
Two large rabbits in a very small hutch
By the sea, on the beach
The choicest fruits are always out of reach.
Our hotel honeymooners are in love without a doubt
They're usually the best of friends, they never scream or shout
But when she wears a bathing-dress the pair keep falling out –
By the Sea, on the Sand, on the Beach.

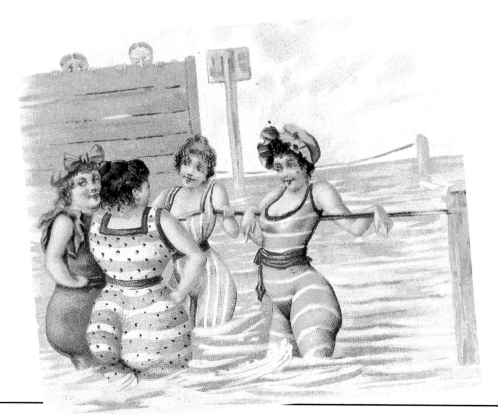

VERSE THREE

By the sea, on the shore
They're wearing rather less than Grandma wore;
Large lumps, big bumps, down among the dunes
Beach balls, golf balls, barrels and balloons
By the sea, on the shore,
When day is done there's so much fun in store –
When darkness falls along the sand the couples all
begin
To bill and coo, and fro and to, it really is a din
And what looks like the moon is just big Nellie diving
in
By the Sea, on the Sand, on the Shore.

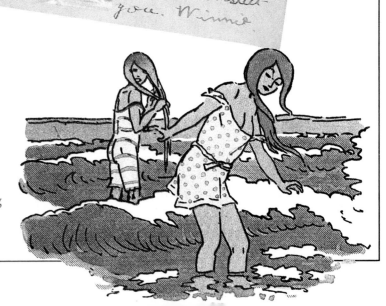

# SAILOR·JACK

(FROM "SONGS OF THE POOPDECK"
BY HAROLD BELL)

I'll tell you a tale of a Matelot fair
With great big muscles and curly hair
He travelled the world both here and there
And he sailed on the *Saucy Sue*.

Now his hair was black and his name was Jack
And he had tattoos all down his back
And all up his front he had them too
And he sailed on the *Saucy Sue*.

Now the girls all loved this Matelot
And they travelled with him to and fro
And they'd go as far as he wanted them to go
On the deck of the *Saucy Sue*.

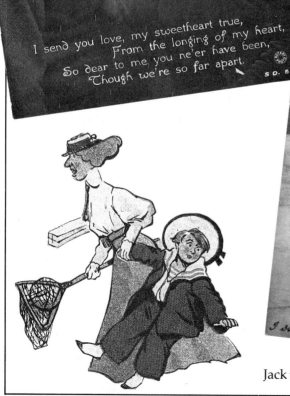

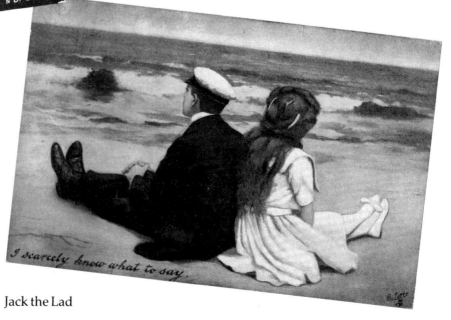

Jack the Lad

He'd woo each maid who came along,
He'd woo her hard and he'd woo her strong
And this was the burden of his song
As he sailed on the *Saucy Sue*.

"Oh your eyes are jet and your teeth are pearls
And your hair is a mass of golden curls
And the rest of you's just like other girls
And that being so, you'll do."

Now he loved a girl whose name was Pat
And she had a figure that was round and fat
But he sailed away and left her flat
On the good ship *Saucy Sue*.

He loved the girls in every port
He'd steal their cash and not get caught
Oh many a tall girl he's left short
As he sailed on the ocean blue.

But now Jack's age has reached three score
He sails the seven seas no more
He sits in a row-boat near the shore
And still nets a nymph or two.

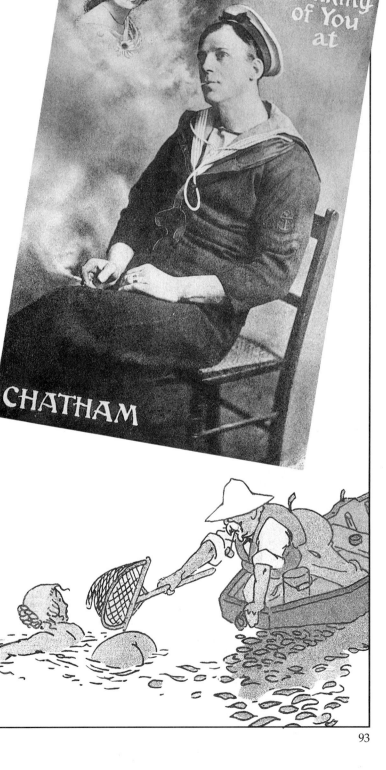

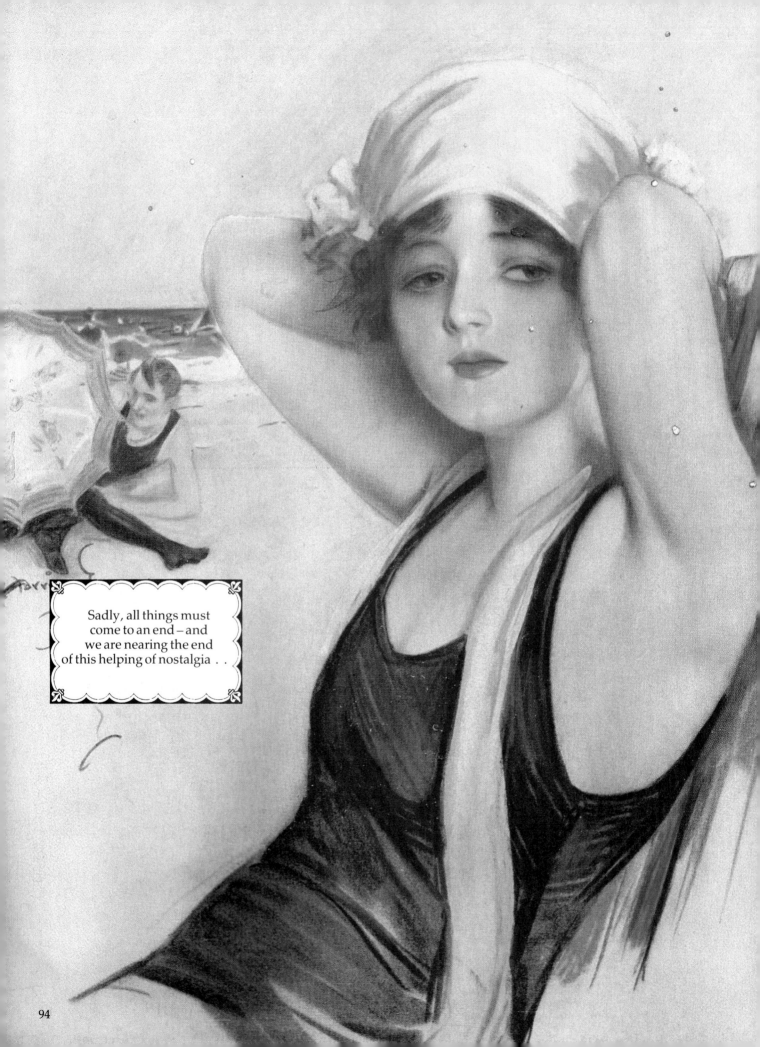

Sadly, all things must
come to an end – and
we are nearing the end
of this helping of nostalgia . .

I hope you have enjoyed this picture book; there is no more
to be said, and but one more thing to be done. In the spirit of
the seaside saucy postcards of those golden olden days –

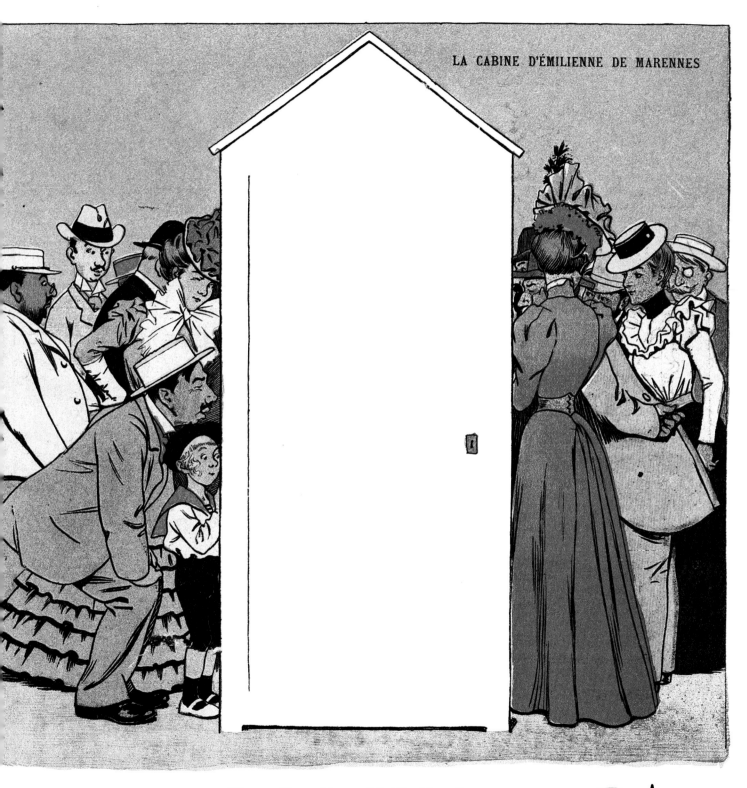

LA CABINE D'ÉMILIENNE DE MARENNES

"HOLD THIS PAGE UP TO THE LIGHT
THEN THE END WILL BE IN SIGHT."

Until the next time . . .

THE END PAGE